PROHIBITION
IN
BARDSTOWN

PROHIBITION
IN
BARDSTOWN

BOURBON,
BOOTLEGGING
& SALOONS

DIXIE HIBBS AND DORIS SETTLES

AMERICAN PALATE

Published by American Palate
A Division of The History Press
Charleston, SC
www.historypress.net

First published 2016

Manufactured in the United States

ISBN 978.1.46713.560.3

Library of Congress Control Number: 2015960008

Dixie Hibbs dedicates this book to all who have shared their research and knowledge with her to tell the Bardstown–Nelson County story.

Doris Settles dedicates her work on this book to W.H. and Jenelle Dearen, her parents, and "Doc" and Clara Wells Oakley, her grandparents, who helped make Bardstown a beautiful place to live and passed on the character traits of pride in ancestry, language and a lifestyle of moderation.

CONTENTS

PREFACE

On a warm summer evening in Bardstown, sitting on the front porch is a long-term custom. The humidity can be stifling, but not nearly so much as the smell of sour mash wafting through town from the distilleries that surround it. But no one minded what could be an overwhelming scent; rather, Bardstown residents saw it as the smell of prosperity. We both recall generations seated side by side, hands busy shelling peas, cutting peaches or reading the newspaper. Our fathers and grandfathers generally held cigars and glasses of bourbon. Women and children might sip lemonade and use advertising or church Bible verse placard fans to move the air along the porch.

Those out for a walk might stop by to chat. Neighbors would come over to provide illumination on some event in the news or find out details from other porches. Stories were told and retold, and gossip was rampant.

It was in these circumstances that much of this book was born. Pleasant memories of summer breezes pushing the sour mash aroma across town are very much cemented in our minds.

As a town steeped in history, much of the local talk revolved around preservation, revisiting the past and the way things were. In the South, the adage "children are to be seen and not heard" was a tenet of our youth, but that didn't stop our youthful ears from gathering and synthesizing what was overheard. Often, questions might be asked of us, allowing us to delve more deeply into an adult world.

PREFACE

And so, from these early beginnings, and from our childhoods steeped in tradition and history, came the desire to document, investigate, research and provide those same opportunities to whomever is interested.

We hope you enjoy our efforts.

ACKNOWLEDGEMENTS

W e would both like to thank Ellen Smith at the Nelson County Public Library for her assistance in locating and organizing information provided by myriad people and organizations. The people of Bardstown and surrounding areas are proud of their heritage and love to regale visitors with tales of the past. It is from this penchant that writers such as ourselves can collect and document stories for future generations.

INTRODUCTION

I live in a section of Kentucky where we have an abundance of "Pretty Women, Fast Horses and Good Whiskey."
—Fielding Merrifield

Representative to the Kentucky General Assembly from Bardstown in the 1840s, Fielding Merrifield had just submitted his first bill and taken his seat when a prominent Whig leader from the mountains inquired who the gentleman was who had offered the bill. Quick as a flash, the Bardstonian was on his feet and, looking toward his colleagues, said:

> *Mr. Speaker, it is with pleasure that I arise to enlighten the gentleman from the mountain tops where the invigorating atmosphere lends strength to all so fortunate as to hale from that section of our Commonwealth, where the huckleberry and the wild grape vine are a distinct part of nature's production and where delightful breezes fan the brow of the weary traveler. But Mr. speaker, I live in a section of Kentucky where we have an abundance of "Pretty Women, Fast Horses and Good Whiskey," where on every side can be observed waving bluegrass and growing crops, and there are no weeds or briars with which to contend and, Mr. Speaker, for the enlightenment of the gentleman from the hill-tops, I subscribe myself as his truly, Fielding Merrifield.*

It would be virtually impossible to write any sort of history of Bardstown without writing about distilling. From its very beginnings in 1776, when Daniel

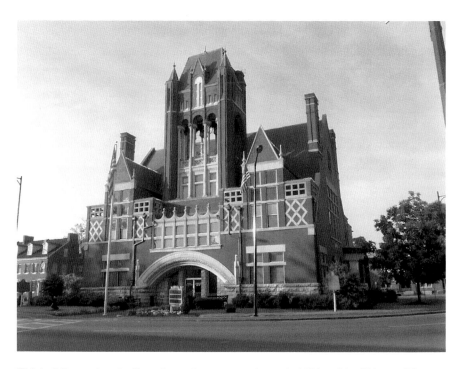

This building replaced a Georgian-style stone courthouse in 1892 and is still in use. The design was the result of an architectural contest, and this Richardsonian-Romanesque creation came out on top. *Photo courtesy of Dixie Hibbs collection.*

Boone's near relative Wattie Boone and his friend Stephen Ritchie first began manufacturing whiskey for sale near Pottinger's Creek, to today's internationally known labels like Jim Beam, Heaven Hill and Maker's Mark, distilling—both legal and illegal—has been an ongoing and highly profitable business in this area for over 250 years, and that includes during the Prohibition years.

In fact, Thomas Lincoln, who then lived at Hodgenville, some ten miles from Boone's Distillery, was in tight circumstances and applied in 1814 for work at John Boone's distillery. Boone gave him a job and found him to be a conscientious and quick employee. Lincoln and his family moved into a house about one mile from the distillery, but this was still too far to go home for lunch. Abraham carried his father's meals to him. The year before the Lincolns moved to Indiana, Abraham had begun assisting his father in the distillery, and as Wattie said, "that boy is bound to make a great man, no matter what trade he follows. And if he goes into the whiskey business, he'll be the best distiller in the land." Of course, where Lincoln located in Indiana there were no distilleries, so he was compelled to learn a new business—and so it goes.

Introduction

Named for Virginia governor Thomas Nelson, the geography of Nelson County has changed dramatically over the centuries. From December 31, 1776, to November 1, 1780, the area known now as the state of Kentucky was called Kentucke County, Virginia. On June 30, 1780, a law creating the three initial Kentucky counties of Jefferson, Fayette and Lincoln was signed by Virginia governor Thomas Jefferson. Nearly two-thirds of Jefferson County—424 square miles of it—was soon to be renamed. On November 27, 1784, Virginia governor Patrick Henry signed the law creating Nelson County out of what had been Jefferson, effective January 1, 1785. On June 1, 1792, Kentucky became the fifteenth state admitted to the United States of America, with a total of nine counties, all of which still exist. Over the years, these initial counties were divided and subdivided, increasing the number of counties but not the size of the state.

Just from the original Nelson County have come, in whole or in part, an amazing total of nineteen additional counties, listed here by date of separation:

Washington	1792	Named for President George Washington
Hardin	1793	Named for General John Hardin
Green (part)	1793	Named for General Nathaniel Green
Bullitt (part)	1797	Named for Lieutenant Governor Alex S. Bullitt
Ohio	1799	Named for the Ohio River
Breckenridge	1800	Named for U.S. attorney general John Breckenridge
Butler (part)	1810	Named for General Richard Butler
Grayson	1810	Named for U.S. senator William Grayson
Butler (part)	1810	Named for General Richard Butler
Daviess	1815	Named for Colonel Joseph H. Daviess
Hart (part)	1819	Named for Captain Nathaniel Hart
Spencer (part)	1824	Named for Captain Spear Spencer
Meade	1824	Named for Captain James Meade
Edmonson (part)	1826	Named for Captain John Edmonson
Anderson (part)	1827	Named for Ambassador Richard C. Anderson Jr.
Hancock	1829	Named for general Governor John Hancock
Marion	1832	Named for General Francis Marion
Taylor	1848	Named for President Zachary Taylor
McLean (part)	1854	Named for Judge Aney McLean

Today, Kentucky is fourth in the nation in number of counties, at 120. In fact, there is a story that circulates in Kentucky lore that a brother and sister, celebrating their ninety-sixth and ninety-fourth birthdays, respectively, had lived in six different counties without ever moving from the home where they were born.

According to the earliest records, the first land claims were made in the area that is now Bardstown in 1775–76. In 1776, of course, the United States of America was formed from the British colonies. In June 1788, the Convention of Virginia decided, by a vote of eighty-eight to seventy-eight, in favor of adopting the Constitution of the United States—with the Kentucky delegation voting eleven against it and three in its favor. The independent spirit of Kentuckians would rear its head once again in less than twenty years when the territory petitioned the government for statehood, which was granted on June 1, 1792, barely avoiding cession to Spain.

In 1775, William Bard, brother of land developer David Bard and a third brother, Richard, came to Kentucke, then a county in Virginia, to oversee the development of a land grant of one thousand acres issued by the Assembly of Pennsylvania. He came as a locater and would not lay out the town until 1780. In the spring and summer of 1780, at the Falls of the Ohio, William talked thirty-three settlers into coming with him to build the town of Salem. The name didn't stick, however. In various historical documents, the town is called Salem, New Salem, Beardstown, Baird's Town, Bard's Town and, finally, Bardstown. Within the next twenty-five years, the small communities of Boston, Bloomfield, Cox's Creek, New Haven and New Hope were settled in all parts of the county. Most of them were along the old buffalo trails, the rivers and, later, the railroads.

From these uncertain but resolute beginnings, the state of Kentucky and the fledgling Union would see great benefit. From its inception, Bardstown was a center for education, culture, law and politics—and from the very beginning, it recognized the talent of the county's whiskey makers. Bardstown whiskey was sought after for its quality.

As the size and number of distilleries grew, so did the reputation of Bardstown becoming an economic center in the state, although almost all of the whiskey produced in the first fifty or so years was consumed locally. But by 1820, small amounts of whiskey were being exported for sale. In addition to the home-based and a few commercial distilleries, Bardstown was thriving with nail and cotton factories, spinning mills and tanneries. By the middle of the nineteenth century, Bardstown had opened its first

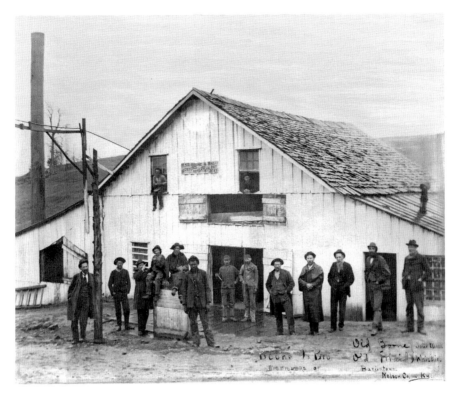

Boone & Brothers Distillery had this photo taken in 1894 for a calendar. Taken in Early Times, Nelson County, Kentucky, this promotional calendar probably hung in many local homes and businesses. Leaning out of the upper right window is Frank Boone. H. Boone, Walter Smith, a son of Frank, Pete Brown, George Robinson, George Eaton, Goo Bradley, Frank "Teapot" Smith, Nick Boone, Jack Nelson, Judge Morgan Yewell and Hiner Beam are also pictured. *Photo courtesy of Nelson County Historical Association.*

privately owned bank—Wilson & Muir—which still operates today. According to the bank's website:

> *The enactment of the National Banking Act of 1863 and the end of the Civil War gave the opportunity for two merchants, Richard D. Shipp and Jeremiah Wilson, to obtain a charter to open the first bank in Nelson County. In February of 1868, ownership interest in the bank was transferred to Bardstown attorney Jasper W. Muir and businessman William Wilson. In 1890 the firm became the Banking House of Wilson & Muir.*

The emergence of new distilleries and larger production of whiskey, along with supporting industries such as cooperages, sawmills and the like, created

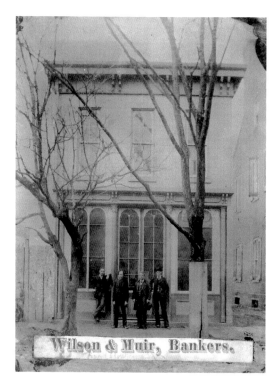

Left: The banks of Bardstown were instrumental in financing the rebuilding of the rusty distilleries in 1933. This 1890 photo is of the Wilson & Muir Bank, founded in 1865 and still in the same location 150 years later. *Photo courtesy of Nelson County Historical Association.*

Below: Farmers Bank was fifteen years old when it bought and remodeled this building in 1923. Farmers Bank helped finance the repair of the distilleries after repeal. *Photo courtesy of Nelson County Historical Association.*

a need for more banks in the county. Each small community—New Hope, Bloomfield, Boston and New Haven—had its own banks. Another bank in Bardstown, the Peoples Bank (1897), was organized during this period. In 1907, Early Times Distillery owner John H. Beam became the first president of the Farmer's Bank & Trust Company. It continues today under the name of Town & Country Bank & Trust.

And of course, money brings political influence. Controversy over the land titles, which was heard at a District Court of Quarter Sessions in Bardstown, drew the best legal talent. Six renowned lawyers formed the Pleiades Club to debate national and local politics. Matters of law, philosophy, religion and ideology were regular servings at these frequently hotly debated sessions, surely fueled by local whiskey. The sale and consumption of alcohol, even in the area where the best stuff is made, has been a topic in Bardstown since these well-known debates.

Shortly before the Civil War, railroads were being laid throughout the fledgling country to open up new markets and provide faster transport of distilled goods. From the earliest years of settlement, goods were shipped

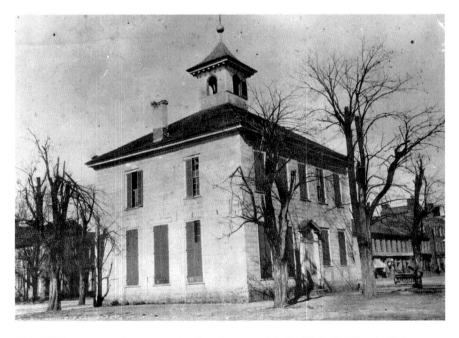

This 1800 stone courthouse was the site of many trials for illicit distilling in Nelson County for over a century. A brick one replaced it in 1892. This is where Prohibition moonshiners and moonshine runners were tried during the 1920s. *Photo courtesy of Nelson County Historical Association.*

on flatboats down the rivers to the Ohio, where they continued on the Mississippi to New Orleans. Shipments upriver were not possible until the invention and wider adoption of the steamboat many decades later. Out of the port of New Orleans, ships heading north along the East Coast to New England carried Kentucky whiskey, rope and tobacco. This took time; time meant aging, and the discovery that aged whiskey had a smoother taste than green whiskey changed the industry. Through the first twenty years, however, Spain was in control of the Mississippi River, forbidding the new country access. This was a huge problem for Kentucky manufacturers, resulting in decades of debate and deceit by both colonists and the Spanish to convince Kentucky to become a Spanish territory. Wouldn't life in America be different if Kentucky had ultimately gone that direction?

Distilling isn't unique to Kentucky. Far from it. Many distillers and farmers in established regions like Pennsylvania migrated to the new territory, bringing with them their knowledge, skills and independence. Reducing the bulk of a corn harvest to something useful as currency and a nonperishable product just made sense. In 1811, more than two thousand "legal" distillers were listed in Kentucky tax rolls; most of them were farmer/distillers. But those who didn't want to pay the taxes were hard to catch.

In fact, the whiskey tax law allowed the early farmer/distillers to own and use any size still under fifty gallons. A fifty-gallon still probably meant you were going to sell at least some of the whiskey, and you were supposed to pay a tax on that still and, later, a tax by the gallon.

In 1790—over a two-year period—what became known as the Whiskey Rebellion shut down the government's efforts to collect liquor taxes in Pennsylvania and other states. Resistance to the tax was equally widespread in Kentucky, but there was an official coverup of the events in Kentucky to make it seem as though the state had less opposition to the tax. There was massive civil disobedience among the Kentucky farmer/distillers, with outright refusal to pay the tax.

Trying to enforce these laws set up a war between federal agents and distillers that has lasted (at least in Kentucky) to the present day on one level or another. Federal agents were manhandled and a few tarred and feathered. There were very few agents in Kentucky, as no one wanted to try to collect this unpopular tax. Finally, Thomas Jefferson repealed this unpopular law in 1802.

After the rebellion was put down, the federal government began prosecuting distillers, including those in Kentucky, for illegally manufacturing spirits. Between 1794 and 1800, the courts brought 177 cases against distillers

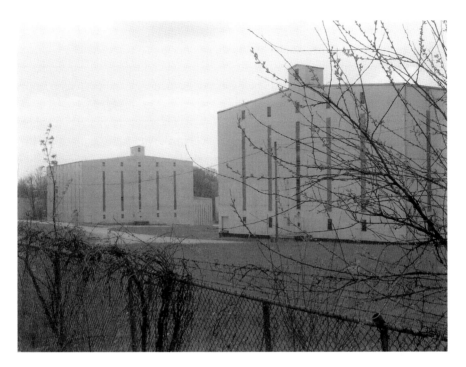

Chain-link fences surround the modern warehouses at bourbon distilleries. *Photo courtesy of Doris Settles collection.*

from twenty-one Kentucky counties. However, Kentucky was spared the military option for the suppression of the Whiskey Rebellion that was felt by Pennsylvania for two main reasons. The first reason was geography—it was simply too difficult to get troops over the mountains to suppress the rebellion in Kentucky. The second reason was the fear that a show of force would drive the state "into the arms of France or Spain." This demonstrates how serious the Spanish influence had become.

Truth be told, though, resistance to this particular law—in addition to the economic devastation created in this area during Prohibition—did more than anything else in this country to engender the tradition (which survives to the present day) of making moonshine (among other things) without bothering to tell the government. And over a century and a half later, this same mentality, born out of an independent and obdurate pioneer spirit, would generate the same sentiment and actions, as what is commonly touted as the highest-quality marijuana product is grown prolifically throughout Nelson and Marion Counties and sold to the international market.

Introduction

Access to the sweet limestone spring water, combined with the sweet corn that grew plentifully, surrounded by large oak trees with which to make barrels, offered an opportunity that the fledgling Kentuckians recognized and grasped, generating a new product: bourbon whiskey. Both a boon and a bust for a raw and emerging frontier society, this new and fully American product, refined in and desired from Bardstown, Kentucky, would become the focus of a nationwide temperance movement in the early twentieth century.

RELIGION AND PROHIBITION

*The reign of tears is over. The slums will soon be a memory. We will turn our
prisons into factories and our jails into storehouses and corncribs. Men will walk
upright now, women will smile and children will laugh. Hell will be forever for rent.*
—Billy Sunday

For some reason, everyone seems to want to know the name of the
very first person to make bourbon. The truth is, no one knows it. The
Reverend Elijah Craig, a Baptist minister, is often recognized as being
the "inventor" of bourbon, but that claim is completely unsubstantiated.
We do know that he was a whiskey distiller in Kentucky during the late
eighteenth century and that his whiskey was probably known as Kentucky
whiskey, or maybe even bourbon, but there's no real evidence to prove
that he was the first person to make bourbon. In fact, according to Mike
Veach, archivist at United Distillers, it is more probable that Elijah Craig's
name was used to fight the prohibition movement in the late nineteenth
century simply because he was a Baptist minister. Smart marketing has
been around for millennia—what could be better than declaring a good
Christian as the "inventor" of bourbon when the distillers had to argue
against forces that quoted the Bible to further their cause?

PROTESTANT RESPONSE

The Baptists were the first religious pioneers in Kentucky, showing up simultaneously with the earliest permanent settlers. In 1776, Reverend Thomas Tinsley was first to proclaim "the unsearchable riches of Christ" in the valley of Kentucky soon after Harrodsburg was established as the first permanent settlement in the state. Several in the Daniel Boone family were Baptists when they came to Kentucky. Indeed, Daniel's brother Squire was a Baptist preacher.

The first two Baptist congregations in Kentucky were located in Nelson County in 1781. As we mentioned earlier, Wattie Boone, the first person to distill in the area, was a Baptist preacher. The Bard family was Presbyterian, and this congregation formed very early. The Methodist churches soon were building in town and out in the county. Methodists were widely known for their anti-whiskey beliefs, but in this whiskey-producing area, they didn't try to condemn all of their neighbors for

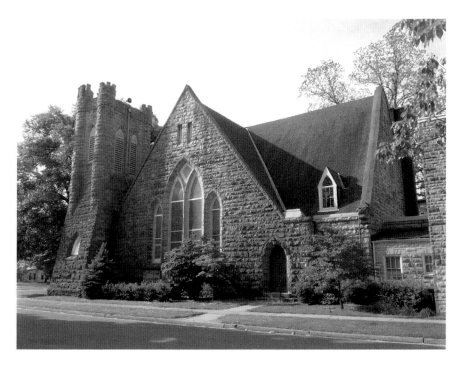

Bardstown Baptist Church was constructed in 1892. The Gothic design and massive walls are still impressing visitors and church members. *Photo courtesy of Nelson County Historical Association.*

manufacturing the "devil's spirit." Traditionally, however, the Protestant faiths have railed against "demon rum."

The Bardstown contingent of Protestants, while much larger in number than its Catholic neighbors, also sported many distilling families of Baptist, Presbyterian, Lutheran and even Methodist faiths in their congregations. It was business during the week and religion on Sunday.

CATHOLIC SUPPORT

But as settlers migrated west following the Revolutionary War, Bardstown became the first center of Catholicism west of the Appalachian Mountains. The first Catholics in Kentucky, William and Frances Coomes and Dr. George Hart, would be found in Harrods Fort in 1776 before moving to Bardstown in 1782. In 1808, four new Catholic dioceses—Boston, New York, Philadelphia and Bardstown—were defined to meet the growing need for leadership of a burgeoning Catholic congregation in the New World. The new diocese of Bardstown covered almost the entire Northwest Territory—west to St. Louis, south through Tennessee and as far north as Detroit.

Bishop Flaget arrived in Bardstown in 1811, nearly three full years after his appointment. He lived in St. Thomas until 1814, when he moved to Bardstown. He wanted to build a monument to God and had been collecting promises or pledges from the first year he arrived to build a cathedral in Bardstown. Lexington and Louisville wanted the cathedral, but Bardstown Protestants knew that this building would be important for the fame of the new city and the economy. Even then, Bardstown had a bent toward generating tourism, which would become very important during Prohibition. Protestants showed their support by contributing $10,000 of the approximately $25,000 of the final cost.

Bishop Carroll of Baltimore requested that John Rogers, the architect and builder from Baltimore, go to Kentucky and help Flaget build churches. Rogers designed a magnificent edifice that stands today as one of the top religious pilgrimage destinations in the nation. Bricks were baked on the grounds, and solid tree trunks cut from the wilderness were lathed in a circular pattern to form the stately columns supporting the roof. When its cornerstone was laid in July 1816, St. Joseph Cathedral became the first Catholic cathedral west of the Allegheny Mountains. Liturgical items and artworks came from Europe. King Francis I of the Kingdom of the Two

This modern image of the Abbey of Gethsemane, the Trappist monastery near New Haven, hides the age and history of the buildings. Father Thomas Merton spent the last decades of his life as a monk here. Year-round retreats bring many visitors. *Photo courtesy of Dixie Hibbs collection.*

Sicilies gave Bishop Flaget several valuable paintings, including *The Martyrdom of St. Bartholomew* by Mattea Preti (1613–1699). Belgian missionary Father Charles Nerinckx may have facilitated the gift of Mathieu Ignacc van Bree's large *Crucifixion*, which hangs over the altar. The *Crucifixion* was a gift of a former French officer, later Monsieur Magallon, who may have liberated it from a Belgium church during Napoleon's war years.

Thousands of people come to Bardstown annually to visit the proto-cathedral. Most have heard of the paintings and come specifically to see them. Church staff, as well as local businesses, enjoy their visits.

The Basilica of St. Joseph Proto-Cathedral is a National Landmark. When the Episcopal see was moved forty miles away to the fast-growing city of Louisville in 1841, St. Joseph became a parish church, hence the name "proto-cathedral." In 1995, Bardstown was named a titular see by the Vatican for its contributions to Catholic Church heritage in America and thus acquired the title of basilica, one of three in Kentucky.

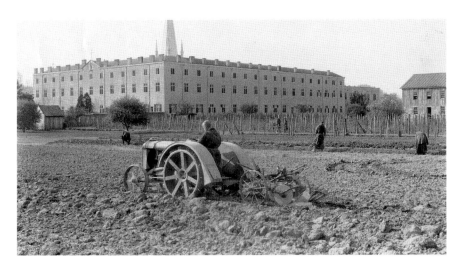

The Gethsemane monks lived off the land, planting, harvesting and praying. This 1924 photo shows the fields and monastery building. They still make and sell cheese, fruitcakes and bourbon fudge. *Photo courtesy of Dixie Hibbs collection.*

With many Catholics engaged in distilling on one level or another, there was a strong, symbiotic relationship between the church and the bourbon industry. A lot of money and land has been donated to the church by distillers. For example, a deed exists showing that Joseph W. Dant, ancestor of the owners of the J.W. Dant Distillery, donated the ground that the Abbey of Gesthemani was built on. He gave it to Father Stephen Badin in 1805 to be used as a school for girls or as a monastery. The Sisters of Loretto established Gethsemani on the donated land in 1818. In 1847, the Loretto Sisters sold Gethsemani to Trappists of Melleray, France. They would start to build the abbey in 1848.

This wasn't the only time distillers supported the rise and expansion of Catholicism in Bardstown. E.L. Miles was another distiller who deeded some of his land over in New Hope to the St. Vincent de Paul parish to construct the church that still stands there today.

As most of us learn in high school history, Catholics were, traditionally speaking in the United States, immigrants from places like Scotland and Ireland. Catholicism wasn't as strong in those areas, and in fact there was much persecution of the religion, which is why many chose to come to America. The Irish and Scots are known for their fine whiskey. So when they traveled across the pond, they brought their Old World recipes with them. One of the early distilleries, McKenna Distillery, was founded on the whiskey recipe brought over by the Catholic Irishman Henry McKenna.

Heaven Hill Distillery, which now owns the brand, explains McKenna's history on its website:

> *Henry McKenna brought his family's whiskey recipe with him from Ireland in 1837 and settled in Fairfield Kentucky, founding his distillery there in 1855. He soon adapted his techniques to the local Kentucky grains, particularly corn, and began producing what became known as "Kentucky's Finest Table Whiskey."*

Nancy McKay, whose father worked for Early Times Distillery, remembered that clergymen and priests didn't speak for Prohibition while she was growing up Catholic in Bardstown:

> *That's one thing I don't think Catholic clergy have ever been against. They haven't been against liquor. I mean, I've never heard a clergyman, a priest, ever say anything about Prohibition was a good thing. And I think the general feeling was that you just can't regulate morals. Which is what it comes down to. And of course, my father was very interested in the repeal of Prohibition because he planned to go back into the whiskey business.*

Archie Spalding, one of the master moonshiners of the largest moonshining operation in Kentucky, perhaps second only to Golden Pond in Trigg County, grew up in a strict, honest, fair household that held closely to its Catholic tenets. Mr. Jesse, as he was known, was Archie's father and the financial backing for the business:

> *Through the years, I have learned much about Mr. Jesse. I learned that Mr. Jesse was a very religious man who practiced living an honest and good life and required the same from his twelve children. He was a good father to them, gentle and loving but strict on his principles of living. The children had religious training from him, too. On a summer's evening, he could be heard to call "prayers." Mr. Jesse would give out the rosary and the litany to the Blessed Mother. Those who know the Spaldings know that this training has stayed with the children their entire lives.*

When Prohibition went into effect, Mr. Jesse thought it an unjust law, but he was busy running a long-standing card game at the Seelbach Hotel in Louisville. When his son Archie—a top student gone to college in Indiana—returned and wanted to go into moonshining with his uncles,

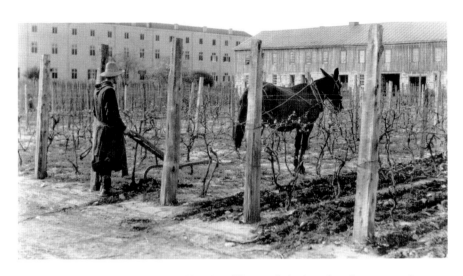

A Trappist monk plows the vineyard in 1924. The monks had produced sacramental wine since their arrival in 1848. In the 1890s, their neighbors were working at the small distilleries along the railroad. In 1924, these distilleries just down the road were closed by the Eighteenth Amendment and now stand rusting away. *Photo courtesy of Dixie Hibbs collection.*

former distillers, Mr. Jesse financed the entire operation. While he never was involved in the making of whiskey himself (aside from being the venture capitalist), Mr. Jesse saw nothing wrong with moonshining and breaking the law. Archie himself frequently said that everybody broke the law, so what was the big deal about him breaking this particular law? Mr. Jesse gave advice to others in the community and was known as the brains behind the Spalding enterprise. Well known to many influential people in Louisville due to his enterprises there, he used his connections to circumvent raids and provide assistance in marketing and distribution to the gangsters in Detroit and Chicago who periodically showed up in Bardstown to buy his product.

But he was a committed Catholic, raising his children in the faith and insisting on adherence to its principles—principles that did not condemn making moonshine or gambling, obviously. Archie was known to have said that drinking and making "'shine wasn't any different than Jesus drinking and making wine at the wedding at Canaan."

And even the monks at Gesthemani, a Catholic monastery just outside Bardstown, were proud of their vineyards. For decades, the grapes grown in their fields were fermented into sacramental wine for their own use, a practice that has, for whatever reason, been discontinued.

A DOWN-AND-DIRTY HISTORY OF BOURBON-MAKING IN BARDSTOWN

We're strong in spirit—a Southern spirit that welcomes you home to one of the Best Small Towns in America. A religious spirit that's appropriate for the home of the first diocese of the West. And a little spirit we call bourbon.
—Bardstown website

THE EVOLUTION OF BOURBON

The first records of distillation and fermentation, or the process of making whiskey, were found in the archaeological digs of Babylon and Mesopotamia, albeit they were primarily used for making perfumes and aromas. From there, it spread across the ancient civilizations and into Europe, finally finding its home behind the walls of the European Christian monasteries. Monks, who fermented and distilled fruit and grain to make alcohol for use in their religious sacraments, probably saved the process during the Dark and Middle Ages.

Most accounts have whiskey-making coming to the areas of Ireland and Scotland between the eleventh and thirteenth centuries with Christian monks, but some records show that Ancient Celts practiced distillation during the production of their *uisgebeatha* (water of life). Grapes were not readily available, hence the focus on beer and whiskey in these regions. Through the decades of perfecting distillation, Scots soon become the world leaders in the production of quality whiskey. By the time the first written record

of whiskey appeared in 1494, production and consumption of whiskey in Scotland had already reached the masses. In that historic record, Friar John Cor received "eight bolls of malt to make aqua vitae," which was enough for the production of around 1,500 bottles of whiskey.

The dissolution of monasteries in Scotland and the high taxes imposed when England merged with Scotland forced the commercialization of whiskey-making and then a movement to take the process underground, distilling by the light of the moon to avoid the smoke's being seen and selling illegally to avoid taxes. Sound familiar?

This is where "moonshine" got its name, or so the story goes. To this day, wisps of smoke on a forested Kentucky hillside may be the only tangible evidence of an active still.

When the Scots and Irish left their homelands and migrated to America and then to Kentucky in droves, they brought with them their knowledge of how to make top-notch whiskey and how to get around whatever laws were imposed on them by others. It became a Kentucky tradition that would bear itself out over the next two and a half centuries.

KENTUCKY CARRIES ON THE TRADITION

For rural folks, making whiskey was a tradition of economic necessity. Farmers harvested their corn in late summer and made whiskey in autumn. Corn in the raw is difficult to transport, but distilling it into alcohol makes it much easier to keep and transport and brings a higher price. And Kentucky farmers were hindered by mountains to the east and Spanish control of the Mississippi River to the west, particularly near Natchez. According to the *Kentucky Encyclopedia*, one mule could transport only four bushels of corn but as many as twenty-four bushels in liquid form. Produce advertisements in 1827 indicated new whiskey sold for sixteen to eighteen cents per gallon and old whiskey for twenty-seven to thirty cents a gallon ("old" whiskey might be only six months old). The same sales list had corn at fourteen cents a bushel and flour at $3.60 a barrel.

Family distilling benefitted farmers economically in a variety of ways. Farmers were, and are, generally cash poor and land rich and frequently used their whiskey as a cash substitute. It was generally accepted that drinking bourbon was considered safer than drinking water from the uncertain supplies of the time. Some Kentucky frontier churches paid their

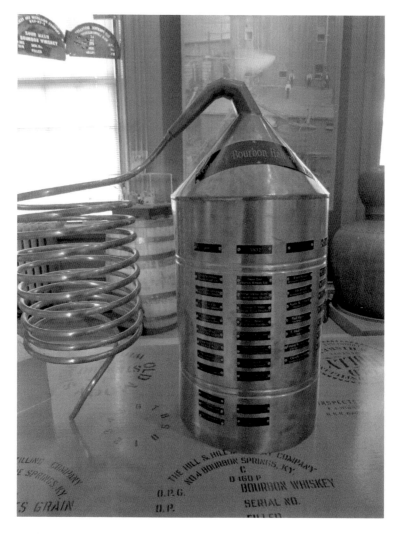

A miniature copper still holds the nameplates of the inductees to the Kentucky Bourbon Hall of Fame and is displayed at the Oscar Getz Museum of Whiskey History in Bardstown. *Photo courtesy of Doris Settles collection.*

preachers in whiskey, which was easier to obtain than currency and in the early days far from standardized. The government even accepted whiskey as a payment for taxes. Now don't you wonder into whose "coffers" those tax payments went?

In Bardstown in 1809, Coppersmith Adam Anthony was able to purchase a building in trade for three thousand gallons of whiskey. As Anthony made and delivered copper stills for the distilleries, his payment for the stills usually

came in promissory notes good for gallons of whiskey made by that distiller. He then traded those promissory notes to Richard Stephens for the east half of lot No. 76, on which was a two-story brick building. At the same time, he paid $1,700 for the west half of the same lot, as quoted on the deed, "where Anthony now lives."

THE INDUSTRY GROWS

According to folklore, it was the preacher Reverend Craig who invented bourbon. As with most inventions, his was accidental. The common tale told about Craig's distilling operation was that it suffered a fire in the 1780s that fried his whiskey barrels, and Craig was too cheap to get new casks. That made him the first in the country to age corn-based whiskey in charred oak casks—a very fortuitous event. The charred casks gave the drink the golden brown color it has today, as well as that undercurrent of smoke, caramel and vanilla flavors that many taste in bourbon (or pretend to, before the senses deteriorate). This is very fanciful but not factual.

Legend has it that Craig, pastor of the "Traveling Church," would bring along his whiskey to his services, encouraging his flock to "get in the spirit" and imbibe as they worshipped. As you can imagine, visions, sightings, revelations and conversions happened on a regular basis. Today, Heaven Hill Distillery produces the bourbon that holds Craig's name in twelve-year "small batch" and eighteen-year "single barrel" bottlings. A highly prized, and similarly high-priced, twenty-one- or twenty-three-year bottling is available, but in extremely small quantities, as you can imagine.

A more likely scenario is that the burning of the insides of wooden barrels was a common practice. New barrels were used as containers to store and transport all types of goods: salted meats, pickled vegetables, vinegar, wines, ale, brandies and, of course, whiskey. This valuable repository was used and then reused after the previous contents had been removed. It was also a common practice to fill the porous wooden barrel with straw and set it on fire to clean and sterilize it. New barrels were burned to prevent unwanted reactions between the new wood and its contents and to remove remaining splinters or shavings.

EXPERIMENTS AND INNOVATION

To make whiskey, the grains (corn, rye, barley) are ground and mixed with water or stale beer. This "sour mash" is scalded, being stirred all the while. After it's fully mixed and blended, it is left overnight, and fermentation begins. Malt (germinated grain) is added and then yeast, after which there are another several days of fermentation. What you have now is called beer, or wash, not to be confused with the beer you drink. Poured into, generally, a copper pot with tubes spiraling out of it, it is again heated, and the distillation begins. The clear liquid produced runs between 140 to 160 proof.

In 1823, another innovation came about. Dr. James C. Crow developed what is known as sour mash at the Pepper Distillery (now the Woodford Reserve Distillery). His experiments would eventually result in a bourbon,

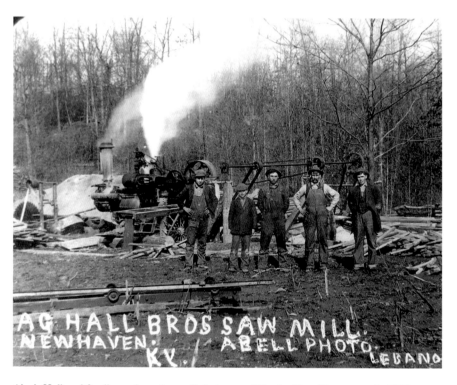

Alvah Hall and family workers show off their sawmill in the New Haven area in 1900. Coopers depended on this type of operation to supply the white oak needed for the bourbon barrels. Many sawmills saw reduced profits as the result of Prohibition. *Photo courtesy of Nelson County Historical Association.*

called "Old Crow," named after him. This method of recycling some yeast for the next fermentation revolutionized the way most bourbons and Tennessee whiskeys have been produced since.

For bourbon to be bourbon, it begins with the mash, which must have a 51 to 79 percent corn base, with the other grains being barley and wheat or rye, depending on the distiller's preference. If you sit outside almost anywhere in Bardstown on a warm and humid summer's eve, the distinctive and cloying aroma of sour mash fills the heavy air. Whiskey must be aged a minimum of two years—although no time limit is set—in a new white oak barrel that has been charred on the inside in order to be called bourbon.

In 1897, the Bottle-in-Bond Act came into effect nationwide, saying that all whiskeys must be aged four years in order to be considered full proof. White oak barrels are used for the aging process, with the insides of the barrels charred to serve as both a filter and a flavoring and coloring medium. Some distillers are experimenting by adding more pieces of charred oak into the barrels to produce an even darker, more flavorful bourbon. The depth of char varies with individual distillers. Other distillers may try to enhance the flavor with new flavoring or techniques of aging. About 3 percent evaporates over the aging process; this is known in the industry as the "angel's share."

BOURBON BY ANY OTHER NAME

By 1786, the whiskey we now call bourbon was known as "Kentucky" or "Western" whiskey—just so people could distinguish it from Pennsylvania, Monongahela or Maryland rye whiskey. No one is absolutely certain from whence the name "bourbon" came, although several different stories exist. Which tale one believes and promotes largely depends on the storyteller. In Kentucky, whiskey from Bourbon meant the county. It had a great reputation and would be requested as Bourbon County whiskey early in the nineteenth century. Buyers in New Orleans liked the French connection and probably spread the news about this spirit.

The name began appearing around 1820, and by the 1870s, it was being used consistently by distillers of the spirit throughout Kentucky. Although bourbon may, in fact, be manufactured anywhere in the world, the best products, as we've noted previously, need the specific attributes found in Kentucky: moderate weather, limestone water and prodigious amounts of fresh corn.

The name can be pretty readily traced back to the French dynasty of Bourbon, largely due to the help Kentucky and the colonies received during the Revolutionary War. In fact, the whiskey, the Kentucky county named Bourbon and the street in New Orleans all share this etymological source. But whether it actually came from the original French connection, because the spirit was at one time distilled in Bourbon County or from New Orleans when it reached that city on its route to elsewhere, no one is absolutely sure.

The following insert comes from a book by one Charles Cowdery, *Bourbon, Straight: The Uncut and Unfiltered Story of American Whiskey*. His account is as likely as any:

> *When American pioneers pushed west of the Allegheny Mountains following the American Revolution, the first counties they founded covered vast regions. One of these original, huge counties was Bourbon County, Kentucky established in 1785 and named after the French royal family. While this vast county was being carved into many smaller ones, early in the 19th century, many people continued to call the region* Old Bourbon. *Located within* Old Bourbon *was the principal port on the Ohio River, Maysville, Kentucky, from which whiskey and other products were shipped. "Old Bourbon" was stenciled on the barrels to indicate their port of origin.* Old Bourbon *whiskey was different because it was the first corn whiskey most people had ever tasted. In time,* bourbon *became the name for any corn-based whiskey.*

Congress, in 1964, declared bourbon "America's Native Spirit," making it the United States' only official distilled spirit. And according to many, it was good for you; many still herald its benefits (in moderation).

Today, bourbon is prized around the world, and many of the old brands are still being imbibed. As in the beginning of pioneer settlement, Bardstown is still the major source for many, if not most, of the bourbon being made. It's what we do!

DISTILLERIES AT PROHIBITION AND THEIR FATES

Once, during Prohibition, I was forced to live for days on nothing but food and water.
—W.C. Fields

Familiar names in Bardstown are also familiar names in the distilling industry. Farmers' stills evolved into legal distilleries in the eighteenth century as pioneers came to Bardstown. While their distilleries might be located outside the actual town, the owners and master distillers lived in Bardstown, and much of the business activities beyond actual production went on there. This talent of making and selling excellent whiskeys became family tradition, as generation after generation went into the industry.

Bourbon's Founding Families

All of these families helped bring the tradition of American whiskey-making into the nineteenth century and right through to the twenty-first century. Not all these people personally produced brand names that are now familiar to us, but they did establish a whiskey-making tradition in their respective families (the whiskeys with which these families became connected are noted in brackets):

Robert Samuels [Maker's Mark] *arrived in Kentucky in 1780 and, although there is no clear and definitive date upon which he began distilling,*

looking at practice at the time it would be a safe bet that Samuels was making whiskey by the 1790s.

Jacob Beam [Jim Beam] *came to Kentucky in 1785 and reportedly built his first distillery three years later. Beam family members, however, not being the sort to lay claim to falsehoods, say that their records indicate that it was 1795 before their forebear actually sold his first barrel of whiskey. However, remember that early distillers usually began by making whiskey for their own use as barter, cash or just drinking.*

Basil Hayden [Old Grand-Dad] *settled in Kentucky in either 1785 or 1796, depending on the source.*

Henry Hudson Wathen [whose family kept the Old Grand-Dad label alive in the late nineteenth century] *began distilling whiskey in Kentucky in 1788.*

Daniel Weller [W.L. Weller] *floated into Kentucky on a flatboat in 1794, and set up stills on his Nelson County farm, producing whiskey/bourbon by 1800. He and his son, Samuel, were farmer/distillers.*

J.W. Dant [J.W. Dant] *began distilling at his Cold Spring Farm near Gethsemane. Directly after the Civil War His son, J.B. Dant, built the distillery and began selling his brand.*

The Nelson County Record, an Illustrated Historical and Industrial Supplement, by Sam Carpenter Elliott, was printed in 1896. This record of local interest included biographies of noted citizens and accounts of local distilleries. Publisher Elliott had formerly worked as a revenue officer for the federal government at the various distilling operations in the area. He wrote in the florid and descriptive style of the age about the "unblemished character" and "unquestioned veracity" of the men and the "beauty" and "accomplishments" of the women.

The registered distillery (RD) numbers follow the names of the distilleries listed here. These are identification numbers for the license to distill given to particular distilleries. When a distillery dissolves, the number stays in the record and may be reassigned to a new distillery.

The following condensed accounts are of the operating distilleries of 1896 and their fates before Prohibition, somewhat modified to reflect modern style and later information but otherwise directly from Elliott's text.

D.S. Wood Distillery, RD #10

Chaplin, Kentucky

David S. Wood of Bardstown bought seven acres of land on Stephens Run near Chaplin on November 24, 1896. Apparently, a distillery had already been built on the property by John H. McBrayer. On the same day, Wood entered into an agreement with distiller Morgan Edelen for him to serve as distiller and manager of the operation and property for thirty dollars per month. They shared profits equally in the sale of a brand of whiskey named "Pride of Nelson." [The Ford Brothers, near New Haven, were also producing "Pride of Nelson," but there oddly is no record of any arrangement or disagreement over the name in either local documents or folklore.] Warehouse receipts show that the D.S. Wood Distillery sold ten barrels of whiskey to John H. McBrayer the following October. Local documents note that the whiskey was produced in June 1897. The distillery was destroyed by fire sometime afterward. Local folklore implies that the fire was, directly or indirectly, caused because the citizens of Chaplin objected to the production of whiskey. The 1882 *Atlas of Nelson & Spencer Counties* shows three different distilleries in that Chaplin precinct, so distilling was not a new or even rare business in the area. The distillery was not rebuilt.

Greenbriar Distillery, RD #239

Woodlawn, Kentucky

R.B. Hayden operated this plant prior to his purchase of Brown Brothers Distillery. Greenbriar Distillery was built on the headwaters of Mill Creek, near Woodlawn. John and Charles Brown were operating there in the late 1870s using the "R.B. Hayden" brand. In 1883, William Collins & Co. was formed by Wm. Collins and J.L. Hackett to operate the distillery as the Greenbriar Distilling Company, still using the "R.B. Hayden" brand and adding "Greenbriar." Collins left the company, and Hackett became president and G. McGowan secretary. In 1891, the distillery was rebuilt. The 1894 map notes that "Belle of Bourbon" was also bottled here at some point. Greenbriar continued operation until 1919, and by 1922, the whiskey had been removed to the concentration

warehouses in Frankfort for bottling as medicinal whiskey. After repeal, a new distillery on the same site was built by local investors. This was later called Double Springs.

HEAD AND BEAM DISTILLERY, RD #405

Gethsemane, Kentucky

Francis M. Head of New Hope and M.C. Beam, former distiller at Early Times, purchased the T.J. Pottinger & Co. plant at Gethsemane Station in 1883 and opened the Head & Beam Distillery. Their brands were "F.M. Head," "Head & Beam," "Old Trump" and "T.J. Pottinger & Co." Beam purchased Head's interest about 1900, and the plant then became M.C. Beam & Company. Taylor & Williams bought the plant in 1910, and it became part of the Yellowstone Plant, which was seven hundred feet west of the J.B. Dant plant where Taylor & Williams was operating.

BELLE OF NELSON DISTILLERY COMPANY, RD #27

New Hope, Kentucky

The Belle of Nelson Distillery Company was located on the Knoxville Branch of the L&N Railroad in New Hope, Kentucky. J.G. Mattingly, of Mattingly & Moore Distillery in Bardstown, established the original brand "Belle of Nelson" in 1877. The brand name was sold to Bartley-Johnson in 1881. He moved the brand and name to this distillery in 1885. It appears they moved into a previous distillery—Kentucky Belle Distillery, RD #373. Geo. M. Hagan, proprietor, was operating Kentucky Belle near Willow Springs Distillery, RD #294, at Coon Hollow. It was not unusual for distilleries to change names but still be located in the earlier buildings. Some accounts say the distillery was built at the Willow Springs plant, but maps of 1891 and 1894 show two different distilleries at two different locations. The company sold out to the trust in 1900, but the brands were still being made by Stoll & Co., a part of the trust in New Hope, in 1905. The Belle of Nelson Distilling Co. was still on the Kentucky state tax records until about 1910.

MATTINGLY & MOORE DISTILLERY, RD #272

Bardstown, Kentucky

In 1896, Mattingly & Moore Distillery was a half mile from the Bardstown courthouse on the Bardstown–Green River Turnpike. Established in 1876, it was here that the first barrel of "Belle of Nelson" was made, as mentioned earlier. The never-failing Morton Spring provided the limestone spring water necessary for making good whiskey. Warehouse capacity was 1,800 barrels. Cattle-feeding sheds were actually built over a running stream to carry off the waste products of the cattle eating the distilling slop that is the feed. In an innovative new method, the slop was piped directly to these sheds from the still house. John Simms and R.H. Edelen were the owners. "Simms & Edelen" is the brand. J.G. Mattingly, in partnership with Thomas S. Moore, built this distillery in 1877 and sold it in 1881 to John Simms, Tom Moore and R.H. Edelen. The "Belle of Nelson" brand was sold to Bartley-Johnson Co. of Louisville. The Mattingly & Moore distillery was located above where Tom Moore built his distillery in 1889. Mattingly & Moore also produced "Morton's Spring Rye" during the 1890s. In 1891, the distillery was known as both Simms and Edelen Distillery and the Mattingly & Moore Distillery. As mentioned elsewhere, this was probably a case of multiple entities contracting for the use of one distillery. In 1916, the firm Simms, Moore and Edelen was operating the distillery, as well as the F.G. Walker Distillery west of town, when circumstances determined that the properties had to be sold to cover debts. The plant was bought by Hermann Bros. of Louisville for $18,000. It was the distributor of "Tom Moore" and also had the option to buy all the 1911–12 crops of Walker whiskey—whiskey already aging in the warehouse. Jim Beam had already purchased the F.B. Walker plant and the 1913–14 crops of Walker whiskey. All useable materials from the buildings and equipment were salvaged during the 1920s, but the distillery did not reopen after repeal.

TOM MOORE DISTILLERY, RD #355

Bardstown, Kentucky

In 1896, Tom Moore Distillery was on the Bardstown–Green River Turnpike one mile from Bardstown. Thomas S. Moore, a practical distiller with fifteen

years' experience, established it in 1889. He had managed the Mattingly & Moore Distillery directly north of this site until 1889. T.C. O'Keefe of Oswego, New York, a full partner in the distillery, was in charge of the distribution. Warehouse capacity was two thousand barrels. "Tom Moore," "Dan'l Boone" and "Woodcock" were the brands. In 1899, he obtained the "Silas Jones" brand from Stoner & McGee. As was the practice of many distilleries, private brands were bottled to serve private clubs and saloons. Prohibition shut down the operation, and all the whiskey that was not stolen was moved to the concentration houses to be later sold to the medicinal companies. The distillery reopened after repeal and continues today under the ownership of Sazerac Inc.

EARLY TIMES DISTILLERY COMPANY, RD #7

Early Times, Kentucky

In 1896, Early Times Distillery was four miles east of Bardstown on the Springfield branch of the L&N Railroad, where a post office and shipping dock had been in place for four years. B.H. Hurt and John H. Beam owned the distillery, and Beam believed in mashing the grains in small tubs and boiling the beer and whiskey in copper stills over open fires, as was common in the early days. "Early Times" and "A.G. Nall" (sour mash whiskeys) and "Jack Beam" (sweet mash whiskey) were the brands. Jack Beam was active in the community and was one of the organizers of Farmers Bank & Trust in Bardstown in 1908. His son Edward and his nephew John Shaunty were both active in the business. Jack Beam died in May 1915, but since his son Edward had preceded him in death a short time before at the young age of forty-two, it was his nephew John Shaunty who succeeded him as president. S.L. Guthrie started working at Early Times in 1907 as an apprentice officeworker but had risen in the ranks to a point that when distillery operations halted in 1918, he was able to purchase the distillery and farm in 1920. Guthrie sold the "Early Times" brand to Brown-Forman after repeal.

HENRY SUTHERLAND DISTILLERY, RD #168

Bardstown, Kentucky

In 1896, Henry Sutherland Distillery was three miles south of Bardstown on the present-day New Haven Road. Established by William Sutherland in 1824, William's death in 1862 brought his son, Henry, to the presidency, with John Beam as the distiller. The warehouse capacity at that point was 2,500 barrels. "Old Sutherland" was the brand. Henry Sutherland operated this distillery until his death in 1916 at the age of ninety. His sons, Hugh, Arch and Donald, continued it until Prohibition. "Bardstown Belle" was a well-known brand, as were several private label brands for various individuals and companies. The warehouses were sealed by federal order, but as was the occasion for many of the distilleries during this time, persons unknown removed a large quantity of Sutherland product. The whiskey thieves of the era took the time to replace the bourbon with water here, which would keep the barrels from collapsing when dehydrated, thereby disclosing the theft. Later, during the dry years, more whiskey thieves would mistakenly drain the water-filled barrels, which by now had acquired the whiskey aroma and color from the barrels but certainly not the taste and proof. This distillery wasn't rebuilt after repeal.

S.P. LANCASTER DISTILLERY, RD #415

Bardstown, Kentucky

In 1896, the S.P. Lancaster Distillery was located one and a half miles north of Bardstown on the Springfield Branch of the L&N Railroad. S.P. Lancaster, in company with his brother, J.M. Lancaster, established the original distillery in 1850. Mr. Lancaster, being a farmer, produced much of the corn used at the distillery. S.P. Lancaster served as the distiller as well as the superintendent. Warehouse capacity was fifteen thousand barrels around 1900. The brands were "Old Lancaster," "S.P. Lancaster," "Marion County" and "Burr Oak." After 1903, the distillery was sold to the Kentucky Distilleries and Warehouse Company (the Trust), and the name was changed to Hume & Lancaster.

F.G. WALKER DISTILLERY, RD #410

Bardstown, Kentucky

In 1896, the F.G. Walker Distillery was situated on College Creek on the western edge of Bardstown. Established by Walker in 1881, in 1897 it was operated by his partner, Charles C. Brown. Morgan Edelen was the distiller and F.V. Bell the beer runner. F.G. Walker Distillery had a good reputation and bottled "Queen of Nelson." When Mr. Walker retired in 1896, the group headed by R.H. Edelen Sr. assumed control and operated the plant as Mattingly & Moore and Simms, Moore & Edelen. Bankrupt in 1916, the plant was sold to James B. Beam for $13,000, with the option to buy the 2,347 barrels of the 1911–14 crops. Beam bought the 1913–14 crop. When distributors listed whiskey for sale, they would list the spring or fall crop. Depending on the weather, and the quality of the grains, a whiskey might be better from one season to another. In this case, Beam wanted only the 1913 and 1914 production. He knew his whiskey. The warehouse capacity at bankruptcy was 200,000. Shut down during Prohibition, thieves took a large amount of the stored whiskey, and fire destroyed one of the warehouses. As was usually the case, arson to hide the theft of the whiskey was suspected. Local farmers used the other buildings to store hay and tobacco.

MURPHY, BARBER & COMPANY, RD #401

Clermont, Kentucky

In 1896, Murphy, Barber & Company was located in Clermont, Kentucky, in Bullitt County, but the fountainhead of the spring that supplies the water for the distillery is located in Nelson County. In 1881, Squire Murphy, A.M. Barber and Calvin Brown established this distillery. Mr. Murphy died in 1893, and Mr. Brown retired soon after, leaving Mr. Barber in charge with John Kurtz as the distiller and Charles Drillette as general manager. The warehouse capacity in 1900 was ten thousand barrels, with brands "Murphy, Barber & Co." and "Clermont Rye." The distillery was operated by Barber, but in 1899, Moses Grabfelder was listed as operating the distillery. It was a common custom to rent the distillery to individuals or a company for a day, a

week or a season, and perhaps that explains a discrepancy in records of who was operating the plant. While Barber continued to operate the distillery, in 1899, Moses Grabfelder is recorded as operating the distillery. Perhaps this connection led whiskey distributor S. Grabfelder & Company to purchase the plant in 1903 and increase the capacity, bottling "Cane Spring," "Echo Spring," "Old Mill Valley" and "Clermont." It closed during Prohibition, and the property was purchased by Jim Beam and Jeremiah Beam for a rock quarry. After repeal, the Beams reincorporated and rebuilt this distillery site as Jim Beam RD #230, which was the original number of the family's closed Clear Spring plant.

.

Gwynn Spring Distillery, RD #371

Hunter's Depot, Kentucky

In 1896, Gwynn Spring Distillery is listed in Hunters Depot, northwest of Bardstown, well off the maintained roads and deep in the woods. Guides were required to reach the business. Jefferson D. McGee and a Mr. Walker established it in the 1870s, but that operation was destroyed by fire and rebuilt in 1880. John B. Stoner was a partner with McGee in this distillery since 1895, with Dee Beam as the distiller. Tax records list this distillery as Lee McGee Distillery from 1885 to 1888, then it is listed as Old Silas Jones Distillery from 1894 to 1899 and then just Silas Jones from 1901 to 1909. These name changes were very common as different people invested or leased the distillery. The registration number is the key to where new distilleries are operating. The "Silas Jones" brand replaced the "Gwynn Springs" brand in the late 1890s. In 1902, Crigler & Crigler operated the plant and produced "Crigler" and "Woodland" brands. N.M. Uri took over in 1903, renaming the distillery International Distillery. This operation bottled "Old International," "Brookwood," "Old Roman" and "Proctor Knott." Uri died in 1909, but the plant continued operating until it was closed by Prohibition, never to reopen.

TAYLOR W. SAMUELS' DISTILLERY, RD #145

Deatsville, Kentucky

In 1896, Taylor W. Samuels Distillery was located a half mile east of Deatsville on the Springfield branch of the L&N Railroad. Erected by T.W. Samuels in 1844 with Stephen Hall as the distiller, the warehouse capacity was fourteen thousand barrels. "T.W. Samuels" was the brand. Both Taylor and his son William Samuels died in 1898, leaving son Leslie B. Samuels to run the distillery. In November 1909, the distillery and its warehouses, which included nine thousand barrels of whiskey, were destroyed by fire. The distillery was rebuilt at the same location, with the Starr Distillery of Cincinnati purchasing a controlling interest in 1913. Leslie Samuels was still manager and part owner and operated the plant until Prohibition. During the late 1920s, all the buildings were demolished except for an old government office. After repeal, a new distillery was built alongside the railroad tracks, about one mile south of the old one.

W.B. SAMUELS AND COMPANY'S DISTILLERY, RD #241

Samuels, Kentucky

In 1896, W.B. Samuels & Co. Distillery was located at Samuels on the Bardstown branch of the L&N Railroad. It was established in 1869 by Samuels and operated in partnership with George R. Burkes, with Robert Masters as the distiller and a warehouse capacity of eleven thousand barrels. It is well located along the railroad tracks, "so that a carload of whiskey can be loaded by two men within 40 minutes' time." "W.B. Samuels Bourbon" and "Eureka Rye" were the brands made. When it became legal to sell liquor at no less than a quart at the distillery, W.B. Samuels petitioned the county court for a license to do so. But local Bardstown citizens signed a petition against the sales, citing their concerns (probably temperance advocates), and he was denied the license. The distillery continued operating until just before Prohibition but did not reopen after repeal. The bottling house was used to house the first St. Gregory School after 1919. The buildings disappeared, and only the foundations remain.

BOONE & BROTHERS DISTILLERY, RD #422

Bardstown, Kentucky

In 1896, Boone & Bros. Distillery was located two miles east of Bardstown on the Loretto Turnpike with a warehouse capacity of two thousand barrels. Wattie Boone and Stephen Ritchie began making whiskey in this area (Nelson) in 1780. The Boone family descended from Wattie and continued the tradition of whiskey-making for more than 116 years. It claims to be the fifth-oldest distillery in Kentucky. Charles Boone purchased the grain and sold the finished product, while Nicholas R. Boone was superintendent of the distillery and Frank N. Boone was the distiller. "Boone Bros." and "Old Maid" are the brands. The distillery continued operation until it was sold in 1903 to Thixton-Millet Company, which moved it to Chicago, Kentucky, in Marion County in 1912. It incorporated with Boone, Ballard & Osborne RD #11. At this point, the name was changed to Thixton-Millet.

BARBER, FERRIELL & COMPANY DISTILLERY, RD #420

Hobbs, Kentucky

In 1896, Barber, Ferriell & Co., as successor of R.B. Hayden & Co., was located at Hobbs, Kentucky, in the western edge of Nelson County. R.B. Hayden's grandfather began distilling in 1796, his father in 1819 and he succeeded his father in 1840. In 1882, Hayden and F.L. Ferriell built the present distillery. After Mr. Hayden's death in 1885, P.S. Barber purchased Hayden's estate's interest in the operation. Warehouse capacity was seven thousand barrels. "R.B. Hayden," "Hayden & Company Pure Rye Whiskey" and "Old Gran-Dad, Nelson County Ky. Whiskey" are the brands.

J.M. ATHERTON DISTILLERIES, RD # 87
MAYFIELD DISTILLERY RD #229
WINDSOR RD # 36

Athertonville, Kentucky

In 1896, the J.M. Atherton Distilleries were just across the Rolling Fork River in Larue County, but shipped everything through the New Haven Depot and so were considered a Nelson County distillery. Mr. Atherton began manufacturing whiskey in 1867 on the present site of the Mayfield House, the other large distillery being the Atherton. Old Johnnie Boone, whose father (Wattie) was about the oldest distiller in Kentucky, made whiskey here for years, and it was here that Thomas Lincoln worked in Boone's Distillery. Taylor Whitehead is the present distiller. Peter Lee Atherton, son of the owner, is in charge of the distillery plant. Warehouse capacity is 150,000 barrels. "Atherton," "Mayfield," "Clifton," "Windsor," "Howard," "Carter," "Kenwood," "Brownfield" and "Baker" are the popular brands.

Jim Beam (far left) gathers with his family in 1910 in front of his home. His son, T. Jeremiah Beam (back of Beam); his daughter, Margaret (seated next to him); and his father, David Beam (far right), are sitting in front of the Roseland Academy building he purchased from the Presbyterian Church in 1909. He added the two-story porch to the 1820 building. *Photo courtesy of Nelson County Historical Association.*

BEAM & HART "OLD TUB" DISTILLERY, RD #230

Bardstown, Kentucky

In 1896, Beam & Hart Distillery was located about two miles north of Bardstown on the Springfield Branch of the L&N Railroad. David M. Beam began the distillery in 1853 and, retiring in 1892, transferred the business to his son James B. Beam and son-in law Albert Hart. The warehouse capacity is ten thousand barrels. James B. Beam is the distiller and Hart buys the grains and supervises the storage and shipping. "Old Tub" is the only brand. This distillery became J.B. Beam and Clear Spring Distillery in 1900. The Clear Springs Distillery was a partnership with James B. Beam as president and Chicago investors Thomas C. Dennehy and J.S. Kenny as co-owners. The "Old Tub" brand was continued, and "Clear Spring" and "Pebbleford" were also produced until Prohibition in 1919. A shipping site and post office on the railroad in 1912–18 at this location was known as Bourbon, Kentucky, and the postmaster was Jim Beam. The distillery was sold and used as a cannery during Prohibition. The remaining warehouses are now owned by Heaven Hill Distillery.

FORD BROTHERS DISTILLERS, RD #461

New Haven, Kentucky

In 1896, Ford Brothers Distillers was located one mile north of New Haven on the Bardstown–Green River Turnpike. R. Monroe Ford was president and general manager with his brothers Thomas R. and Curtis J. as silent members. The mashing capacity was fifty bushels a day. Richard Bowling, who distilled for Ford Brothers, worked for E.L. Miles & Co. of New Hope in 1880. Of Bowling, it has been said that "he is a believer in signs as displayed by the moon. When he is making whiskey in the dark of the moon he always exceeds 4 gallons per bushel, while in the light of the moon he can only produce about 4 gallons per bushel." Green Price was the assistant distiller and superintendent of the mash floor. "Pride of Nelson" was the only brand. Prohibition closed the operation, which didn't reopen after repeal, but the brand was used by S.L. Guthrie at his Fairfield Distillery RD #42 after 1936.

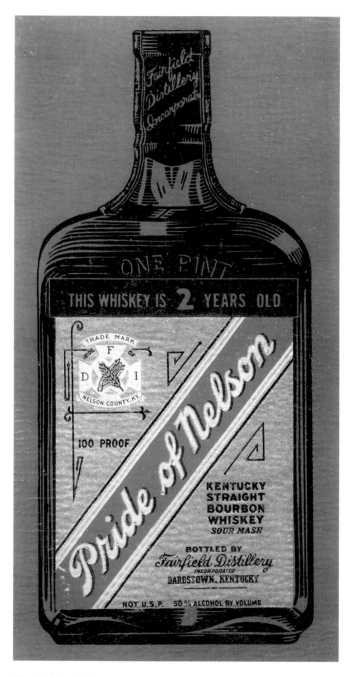

The "Pride of Nelson" was an old name on a new bottle. The brand was used by Fairfield Distillery after 1936, when the Ford Brothers Distillery didn't open after repeal. This is a drawing. *Courtesy of Nelson County Historical Association.*

H. McKenna Distillery RD #111

Fairfield, Kentucky

In 1896, McKenna Distillery, located in Fairfield, Kentucky, was making "old-fashioned handmade whiskey." Henry McKenna began operation in 1855 with a flour mill, making less than one barrel of whiskey per day on the side. In 1883, he built a new brick warehouse, which increased his output to three barrels a day. He died in 1893, leaving his sons to continue the business. Warehouse capacity when his sons took over was eight thousand barrels. With Daniel McKenna as the general manager, James S. McKenna as assistant manager, Stafford McKenna as traveling man or salesman and Patrick Sweeney, who entered the distillery in 1860, as distiller, the men produced "H. McKenna—Old Line, Handmade Sour Mash Whiskey" as their only brand. H. McKenna Distillery continued production until 1917. After 1919, all the barrels of whiskey were removed to a warehouse in Louisville for bottling as medicinal whiskey. After repeal, the distillery and warehouses were repaired, and it became the second in the county to resume production in 1934. McKenna's sons, Jim and Stafford McKenna, were the ones to reopen the operation. The "H. McKenna" brand is now owned by Heaven Hill Distillery.

Sugar Valley Distillery, RD #442

Bloomfield, Kentucky

In 1896, Sugar Valley Distillery was located in the outskirts of Bloomfield, northeast of Bardstown. David T. Brooks and Bodine McClaskey & Son owned it in 1889, distributing the brand "Sugar Valley." Located along the Bloomfield branch of L&N Railroad, the plant was in a convenient location for shipping. In 1894, it is noted as the Ashton Distilling Company: B. McClaskey & Son. With a capacity of seventy-five bushels per day, it was capable of storing 2,100 barrels of whiskey and continued to produce whiskey until 1916. Records show Sam McClaskey signed the withdrawal report and paid the taxes in 1923 on the 1916 whiskey. It did not survive Prohibition.

WILLOW SPRINGS DISTILLERY, RD #10

Coon Hollow, Kentucky

In 1896, Willow Springs Distillery was located a few hundred yards from Coon Hollow Station. Owned by P. & M.J. Cummins, it was operated by Martin J. Cummins. "Willow Springs" (sour mash) and "Mini Club" (sweet mash) were the brands. Willow Springs was located a half mile from Belle of Nelson Distillery, one mile east of New Hope near the boundary of Nelson and Marion Counties. These two and the Nelson County Distilling Company's Coon Hollow are very close together, which sometimes has caused mistaken identification in records.

THE NELSON COUNTY DISTILLERY COMPANY
COON HOLLOW, RD #294
BIG SPRING DISTILLERY, RD #379

Coon Hollow, Kentucky

In 1896, Nelson County Distillery Company was located in Coon Hollow, Kentucky, in the southern part of Nelson County on the Knoxville branch of the L&N Railroad, operating two distilleries: Coon Hollow and Big Spring, with six warehouses. Each and every barrel of "Coon Hollow" and "Big Spring" whiskey was inspected daily by the chief warehouseman to avoid excessive leakage. These two distilleries were joined under the Nelson County Distillery name in 1880. The Nelson County Distillery Company began a newspaper called the *Coon Hollow Herald*, directed mainly to physicians and pharmacists to promote the whiskey. The Trust bought the operation in 1900 and closed the distilleries. The buildings were dismantled, though the brands continued to be produced by other plants.

COLD SPRING DISTILLERY, RD #240

Gethsemane, Kentucky

In 1896, Cold Spring at Gethsemane Station on the Knoxville branch of the L&N Railroad, in the southern part of Nelson County, was being operated by J. Bernard Dant and Crittenden Clark as distiller. It had been built by J.B. Dant, son of J.W. Dant, after the Civil War. In the 1880s, Dant contracted with Taylor & Williams (whiskey wholesalers) to produce the brand whiskey "Yellowstone," named for the national park established in 1872. It continued as J.B. Dant or Cold Spring Distillery until it was sold to Taylor & Williams Company, of which Mr. Dant was president. In 1910, Taylor and Williams purchased M.C. Beam's Distillery next door, and after that, the only brand used was Taylor & Williams. Tax records list J.B. Dant as owner from 1885 through Prohibition. It was reopened after repeal as Dant & Head Distillery. Its barrels were made locally, with Dant personally selecting the timber to be used in the barrel making. "Nelson County Club" (pure rye) and "Cold Spring" (sour mash whiskey) are the brands.

WALNUT HOLLOW DISTILLERY, RD #432

Howardstown, Kentucky

Located near Howardstown, Kentucky, this operation was first established by Fred Bray in 1831. Then, James Mahoney, father of James H., operated it until 1888, when J.H. entered into a partnership with Miles A. Howard. "Walnut Hollow" is the brand. In 1895, James H. Mahoney bought Mr. Howard's interest and became the sole owner. Uncle Richard Bowling was the distiller. He is purported to have been "an honest and clever black man who has made whiskey since 1845." In 1896, Mahoney had disposed of his entire production to an Indiana firm, a feat any distiller would celebrate. There is very little information about this distillery except that it continued to operate until Prohibition.

E.L. MILES DISTILLERY, RD #101
NEW HOPE DISTILLERIES, RD #146

New Hope, Kentucky

In 1896, E.L. Miles Distillery and the New Hope Distillery were located in New Hope, Kentucky, on the Knoxville branch of the L&N Railroad. The whiskey-making operation, established in 1796 by Henry Miles, has been in operation continuously since except for three years during the Civil War. Edward L. Miles built the distillery in 1867 with Thomas H. Sherley as the distiller.

The New Hope Distillery was established in 1875, operated by Miles and Sherley as well. Twenty years later, the capacity of the two distilleries had increased to seven hundred bushels a day.

In 1894, the E.L. Miles Distillery was also run as Twin Spring Distilling Company; Adams, Taylor & Co.; and the New Hope Distilling Company and Adams, Taylor & Company—two separate distilling buildings with the

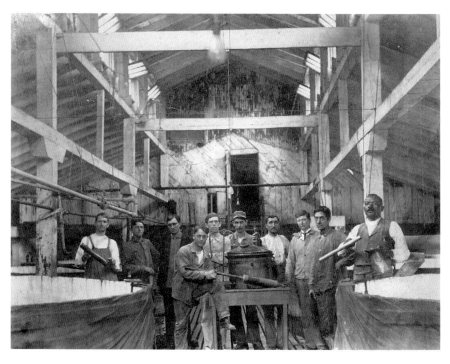

The location of this photo was a mystery until the light bulbs were discovered on the picture of the fermenting room. Only the E.L. Miles Distillery of New Hope had incandescent lights in 1894. It was a posed picture, as everyone seems to be clean and in their best work clothes. *Photo courtesy of Nelson County Historical Association.*

expertise of talented whiskey men. The warehouses and distillery buildings were made of brick and heated (a very unusual feature), but even more surprising is that in 1894 they installed electricity with incandescent lamps. Bardstown had yet to install electricity throughout the town itself. The distillery and warehouses, built on both sides of the railroad, used elevated whiskey pipes running from the distillery to the cistern room for the filling of the barrels. Mr. Sherley died in 1900, and Miles operated it until he sold the distillery to the Trust shortly afterward. The plant was never used again after Prohibition. Only scattered foundations are found one hundred years later.

The Whiskey Trust

Most monopolies of the late nineteenth century prospered by dominating their industries. But the Whiskey Trust was beaten by the bourbon industry and ultimately failed.

During the late nineteenth century, many industries evolved into monopolies as one producer dominated an industry and either organized its competitors within its monopoly or drove them out of business. The distilling industry was no different. A variety of distillers vied for control of the industry, but Julius Kessler, an Austrian immigrant who manufactured his self-named whiskey in Leadville, Colorado, came to dominate them. Kessler bypassed the middleman by selling direct to saloons, which allowed him to sell his whiskey at a lower price than his competitors could. Instead of competing with Kessler, in 1887, other distributors joined Kessler in the Whiskey Trust, formally known as the Distiller's Securities Corporation. This monopoly dominated the spirits industry throughout the country. Kessler limited the number of major producers, closed more than half of the large distilleries controlled by the trust and artificially created a whiskey shortage that drove up prices. The trust defended its actions by claiming that its products were purer and of higher quality than the locally produced moonshine.

But in reality, the distillers of the Whiskey Trust produced blended whiskeys of neutral spirits with artificial flavoring, a technique that clashed with those of traditional bourbon producers. The bourbon producers refused to change their distilling practices or join the monopoly, and the trust wasn't strong enough to run them out of business. The hundreds of independent and small-scale producers created an even larger headache

for the Trust, which was also the target of government investigations for tax evasion and bribery of public officials.

The death blow, however, was Prohibition. When alcohol production became illegal, most distilling went underground. When Prohibition ended in 1933, strong federal antitrust laws and stringent alcohol regulations prevented the re-creation of the Whiskey Trust.

When the national Whiskey Trust split up, the Kentucky Distillery and Warehouse Company was one of the three that remained. It was commonly referred to as "the Trust" or "the Bourbon Trust." It had been operating in the Bardstown area since the 1890s. The intention of this organization was to buy up small operations and hold the inventory to help control supply and prices. The Trust bought up S.P. Lancaster Distillery in 1903, the Belle of Nelson Distillery in 1900, the Nelson County Distilling Company in 1900, E.L. Miles Distillery in 1901 and Atherton Distilleries (Larue County) in 1899.

TEMPERANCE

What started as a moral crusade against drunkenness in the first half of the nineteenth century, mostly by Protestant churches and women's suffrage supporters, became an effort to end alcohol use completely by the end of the century.

These campaigners began by trying to make the country dry one precinct at a time, usually being roundly defeated—or, if a precinct did vote dry, its residents continued to drink wet. Very little change was happening, especially in Bardstown because whiskey-making and selling was a huge part of the growing economy here after the Civil War. However, even in Bardstown, the temperance movement seemed to become part of the Nelson County community from the mid-1800s to Prohibition.

LOCAL TEMPERANCE MOVEMENTS

In an 1827 journal, seven local men, including Jacob Curtz, second cousin to Abraham Lincoln, signed a temperance pledge. The pledge bound any one of the signers who broke the pledge to buy each of the others "one pair of shoes, lined and bound of good leather." The journal doesn't record if anyone broke the pledge. The same journal noted that whiskey sold for thirty-seven cents a gallon at the time.

This pre-1890 view of the business area of Bardstown looks north from the courthouse. Except for the telephone poles, this was how Civil War soldiers saw it when they went through in the 1860s. In 1900, two new corner buildings changed the view. *Photo courtesy of Nelson County Historical Association.*

Local ministers are recorded as preaching against alcohol. As early as 1831, one local temperance organization was called Cox's Creek Temperance Society. Local minister Reverend William Rannells was elected president, with three other gentlemen filling the other offices. In 1832, Reverend H.H. Kavanaugh was noted in the newspaper as being a Methodist Episcopal minister giving a sermon on temperance at the Baptist meetinghouse on North Second Street. Presbyterians, Methodists and Baptists all used this meetinghouse from 1812. The *Bardstown Gazette* advertised in September 1855: "Sons of Temperance Nelson Division, No. 48 meets every Saturday night at its Hall, corner of Main and Arch Streets." Thirteen years later, another local organization would meet at this same hall with somewhat the same goals.

The minute book of the local Templar Lodge No. 165 was recently discovered and covers the period from 1871 until 1878. This was the national organization started in 1851 known as the International Order of

Christian Templars. The members were united in their desire and efforts to prevent people from indulging in intoxicating liquors. The minutes reflect the "obligation"—an oath to refrain from "consuming intoxicating liquors drank as a beverage"—required of all members. This was an organization for both men and women that raised money with socials, picnics and other events. It rented the hall on the second floor of the building on the corner of Arch and Main Streets from D.J. Wood. It collected membership fees and raised money in other ways. Their expenses were rent, refreshments and a load of coal to heat the hall.

The most common entry was the accusations toward members: "_Name of accused_ drank whiskey on ____ day of ____ month." A three-person committee was appointed to meet with the accused and investigate the charges. Sometimes, a member would confess his failing before he was accused. After the investigation, a report was submitted, and the accused would confess his guilt and ask to be given another chance. A time period of

A photographer caught Sam Rodman and Anna Lee Wood (later his wife) as they were walking on the first block on North Third. This picture also records the construction of water lines. Several of the buildings in the background were occupied by taverns or saloons. *Photo courtesy of Nelson County Historical Association.*

punishment was allowed, but most often the member was given the chance to "re-obligate" himself to refrain from intoxicating liquors.

This group started the lodge in 1868 and represented both town and church leaders. The members attended other lodge meetings, in and out of the county. It must have been a disappointment to the elected officers when their members would be obliged to confess a "fall from grace." The only thing worse was when an elected officer fell off the wagon and had to confess his (or her) shortcomings. There are some entries where a husband and wife withdrew from the lodge in a difference of opinion about a resolution or action. Sometimes members were expelled and not allowed to return.

Many women supported Prohibition quietly and as such did not influence it much. However, a few women who were vocal about their support for Prohibition greatly contributed to the anti-alcohol sentiment in both violent and subtle ways. The emotions these activities triggered created a growing public response, much in the way that Harriet Beecher Stowe's *Uncle Tom's Cabin* inflamed the public prior to the Civil War.

CARRIE NATION

Bardstown and the surrounding area were hard hit economically and socially when pietistic Protestants nationwide followed the divine vision or mad rantings of, coincidentally, another Kentuckian: Carrie Nation. Nation was born in Garrad County, Kentucky. Growing up sickly in a poor and itinerant family that was beset with mental illness, Carrie (or Carry) Moore married Dr. Charles Gloyd, an alcoholic, who died shortly after the birth of her only daughter.

In 1874, Carrie married David A. Nation, an attorney, minister, newspaper journalist and father nineteen years her senior. After what she believed to be a prophetic vision telling her to smash bars, she became more violent, smashing bottles with first rocks and then a hatchet. With other women or by herself, she waged war on barrooms anywhere she came across them. She even applauded the assassination of President William McKinley in 1901 since she was convinced that he was a "secret drinker of alcohol"—because, of course, drinkers always "got what they deserved." In 1919, eight years after her 1911 death, her dream became Bardstown's nightmare. The Eighteenth Amendment was passed, banning "intoxicating liquors."

In Bardstown just before Prohibition, Ed Boblitt operated a saloon. His son Vella eloped with Barbara Beam, daughter of Ed Beam and

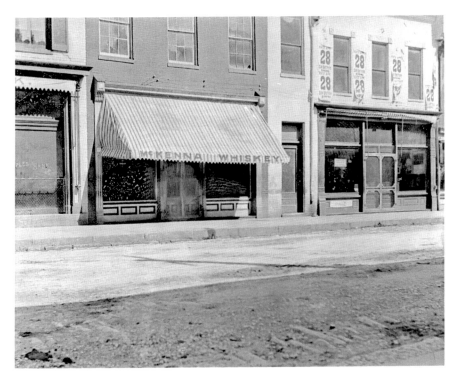

The east side of Main Street had several saloons and taverns and was not generally used by ladies from the late 1890s to the 1920s. The patrons might embarrass them. The McKenna on the awning advertises the whiskey produced in Fairfield, Kentucky, by H. McKenna. *Photo courtesy of Dixie Hibbs collection.*

granddaughter of Jack Beam. The newspaper headlines read, "Sixteen-Year-Old Daughter of Distillery Owner Runs Off to Marry Her Childhood Sweetheart, Son of a Saloon Keeper." The Beams owned the Old Tub Saloon on Main Street. Next door, Robert and Ogden Stiles operated a poolroom. The new Old Kentucky Home hotel also provided its guests with a saloon.

Other people who owned saloons in the early 1900s were Whelan & Johnson, Conley & McGill, James Moore and Thomas Beam. These saloon owners were cited by the Commonwealth of Kentucky for "selling liquor to a minor, without a written permission from a parent, or for selling liquor to an inebriate, a person in habit of becoming intoxicated by the use of such liquors." Fines were imposed and paid.

MARY HUNT

Mary Hunt was a teacher on a mission. In the 1870s, she was able to convince her Massachusetts School Board to agree to temperance instruction in schools. Hunt continued to other schools within the state and campaigned there to achieve the same goal. Nearing the end of the decade, she was invited by Frances Willard to present at a meeting of the Woman's Christian Temperance Union. A year later, Hunt became the national superintendent of the Department of Scientific Temperance Instruction in Schools and Colleges. From there, she asked the members of the WCTU to petition their school boards to use temperance textbooks in their curriculums, as she had done years earlier. However, Hunt was not satisfied with the outcome and created the Scientific Temperance Instruction Movement, where she worked to ensure the election of pro-temperance candidates.

Besides using textbooks advocating complete abstinence, she supported teaching the effects of alcohol and drugs. Her idea was ultimately very successful; by the beginning of the twentieth century, nearly every state and territory warned students off of alcohol through their schooling. However, instead of educating children on alcohol use, the books Hunt chose were meant to mislead and scare them away from trying it. This was a clever maneuver and definitely caused more people to abstain from alcohol than the textbooks would have if they had stated only the actual dangers of the substance. Hunt took a far subtler approach to Prohibition than did Carrie Nation. But Hunt's actions affected millions of schoolchildren. Many chose to remain abstinent even as adults because of their temperance educations.

Hunt's philosophy was implemented in Bardstown as well. On October 27, 1922, Temperance Day was observed in the public schools of the state. The goal was not only to teach the young ones the evil effects of intoxicants but to respect the laws—especially the prohibition laws—that were being visibly violated on a daily basis all around them. In fact, the irony of this is that many of these same children were being asked to help distill, bottle and transport the very whiskey being railed against in their classrooms. In retrospect, the irreconcilable paradox that these children (and families) faced was hardly fair.

THE ANTI-SALOON LEAGUE

It was the Anti-Saloon League (ASL) that put political power behind the temperance movement when it bullied its way into politics. Formed in 1885, the Anti-Saloon League attempted to combat the growing number of saloons throughout America. Closely tied to evangelical Protestant denominations, it had a critical role in the national Prohibition movement. Efficiently run, the board members of the league wrote bills that would be proposed, increased their public appeal, lobbied members of Congress and orchestrated several protests throughout the country. Under the popular motto "The Saloon Must Go!" they held the uncompromising belief that saloons were incompatible with American society. In the end, their focus expanded beyond saloons to do away with any notion of alcohol in society.

To accomplish these goals, their two main focal points were to establish a new Prohibition legislature made up of candidates chosen for their anti-alcohol leanings and to enforce existing laws. Instead of aligning with the already existent Prohibition Party, they started a radical attempt to get politicians elected who could accomplish their goals in the Democratic and Republican Parties. The ASL did this not by controlling a majority of Americans and forcing a change of heart but by controlling enough voters to swing a close election toward the "dry" candidate. Enough career politicians ultimately lost their jobs that any incumbent or political challenger was a fool to oppose the league's views. Prohibitionists used this power to get, first, an income tax amendment passed so the government would not have to rely on the whiskey tax to pay its bills and then the Eighteenth Amendment, creating the prohibition of the sale of alcoholic beverages in the United States.

The ASL was able to proliferate throughout American society, visiting churches, distributing pamphlets and campaigning for candidates who would represent its core values in both local and national government. The appeal of the organization expanded because it also supported women's suffrage, aid to immigrants, improvement in workplace conditions and an end to monopolies. The Anti-Saloon League probably had the most direct impact on Prohibition, creating a political system that produced candidates who supported its cause and swaying the minds of American voters. There is little evidence, however, that it existed in Kentucky until the mid-twentieth century.

Prohibition really got its start in 1918, when the government passed "Wartime Prohibition," prohibiting the distilleries from making beverage alcohol so they could supply the government's war effort in Europe. Even

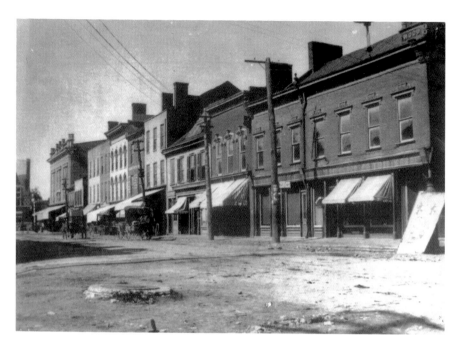

Looking southwest from the corner of Arch and Main Streets in 1905, you can see eleven buildings housing fifteen different businesses. The third building from the right is Spalding's Dry Goods, which has a skylight on the roof. The street would not be paved until 1918, but stone walkways were at each corner. The round object in the foreground is a well cover—one of the many reservoirs for fighting fires. *Photo courtesy of Dixie Hibbs collection.*

when the war ended in November 1918, the government simply extended the law because the Eighteenth Amendment was well on its way to being passed and was indeed put into effect in January 1919. The law called for Prohibition to start one year to the day after the ratification of the Eighteenth Amendment. National Prohibition officially started on January 16, 1920.

But Kentucky beat everybody to the punch—amazing for a state whose identity in many ways is tied closely to the making, selling and drinking of alcohol. A proposal to ban alcohol in Kentucky was approved by the state House in 1914 but died in the senate. Undaunted, Kentucky's dry forces pushed a prohibition bill through the legislature in 1918, and voters approved it the next year. But this was largely academic once national Prohibition began.

America's little experiment with Prohibition was a failure. After thirteen years of corruption, speakeasies and an empowered mafia, the United States repealed Prohibition in 1933. With the federal ban on alcohol removed, authority over alcohol shifted to the states. Not a single state chose to continue the experiment.

A DEVASTATED ECONOMY

I do not care to live in a world that is too good to be genial; too ascetic to be honest; too proscriptive to be happy. I do not believe that men can be legislated into angels—even red-nosed angels.
—*Henry Watterson, owner and editor of the* Louisville Courier Journal, *1913*

Although thirteen years later (on December 5, 1933) the Eighteenth Amendment was repealed and Prohibition ended, enforcement of the amendment through the Volstead Act had brought an abrupt halt to a vast industry that involved hundreds of thousands of individuals. In Bardstown, saloons lined the east side of North Third Street, flanked on one end by Wilson Muir Bank and on the other by Peoples Bank. As the saloons were frequented only by men (and women of less-than-sterling repute), respectable women who needed to go to both banks would do their business at one corner, cross the street and walk the length of the block, re-crossing at the other corner to attend to business at the other bank.

Historically, inns and taverns such as the Old Stone Inn (now the Old Talbott Tavern), Captain Bean's, Duncan McLean's, Widow Grundie's and Moses Black's drew men wanting to play cards, enjoy a drink with friends and argue politics or religion. Only one of these establishments was to continue operation after Prohibition ended.

In January 1920, sixteen distilleries were still operating after the World War I cutback. When Prohibition closed those distilleries, the unemployment rate in Bardstown skyrocketed. In a single day, workers at the area's largest

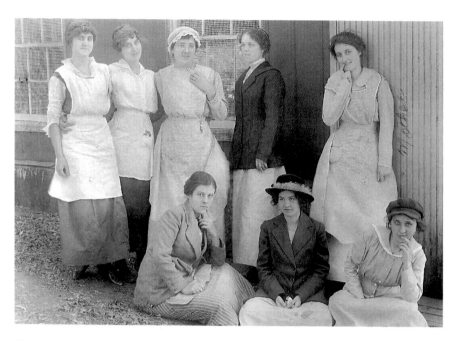

These women are working at Yellowstone Distillery Bottling House in New Hope about 1914. Women were hired for the bottling as they were more careful in labeling and handling the bottles. Newspaper advertisements for bottling house girls continued until 1919. *Photo courtesy of Nelson County Historical Association.*

industry were without jobs. Farmers lost their markets for corn and grain. Grocers lost their customers. Clothiers had no one to sell to.

Many distilleries had to be sold, and all had been shut down. Mattingly & Moore at Bardstown was bankrupt. Athertonville in nearby LaRue County was being dismantled. Clear Spring (near Nazareth), Dant (near Gethsemane) and F.G. Walker and H. Sutherland (outside Bardstown) were auctioned in 1918. The local saloons closed. Everyone was stocking up on spirits, not knowing when they would be able to legally obtain them again. The distillery owners were allowed to keep and store at their homes a large supply of their products.

The pharmacies awaited the official bottles of medicinal whiskey to offer to their customers. Everyone was worried. They'd had a taste of the effects during wartime prohibition, but this was not a temporary move. It was now a national law, and it would take an action by Congress to remove it.

Local wheelers and dealers were planning their moves. A chance meeting at the barbershop hangout one morning early in the 1920s offered one land speculator a golden opportunity. Jim Beam of Clear Spring Distillery had been

having lots of trouble in the past two years getting the owners of barrels of whiskey in his warehouses to pay their storage so that he could pay the tax. Each year, the unpaid tax bills piled up, and his future seemed bleak. Back and forth the men talked about the future of the distilling industry. Was the government going to confiscate all the whiskey and demand all the taxes be paid?

Jim kept getting more and more upset and finally, in a loud voice, declared, "For $10,000 I would sell it all—lock stock and barrel!" Will Stiles was a buyer and seller of almost anything and happened to be within earshot. He had bought and sold a freight car full of raincoats, hundreds of mules and acres of land. He spoke up and said, "I'll give you $10,000 for it." Beam had made his statement, and all in the barbershop had heard him. What would he do? Stiles went to Wilson & Muir Bank down the block, borrowed the $10,000 and bought it all: property, equipment and barrels of whiskey. This meant he also got the responsibility of dealing with the federal government about the legal problems and taxes. Less than a year later, the newspaper ran in large headlines: "Whiskey Sold to Medicinal Spirits Company for $400,000." What a steal! What a deal! Beam's problems were solved, but his solution made Stiles a lot of money. Stiles went on to invest in the economy, buying buildings and farms and setting up businesses. He made enough to cover the bets when out-of-town politicians or investors came to Churchill Downs for the races. He may have even staked Beam again—who knows?

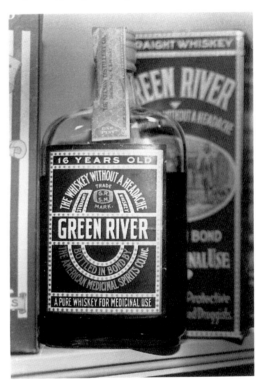

Green River—"The Whiskey without a Headache"—is sixteen years old in this photo, which means it was made before 1910 by the Nelson County Distillery. It was bottled by the American Medicinal Spirits Company about 1925. This bottle has not been opened, but you can still see the level of evaporation that has taken place since bottling. *Photo courtesy of Nelson County Historical Association.*

PROHIBITION IN BARDSTOWN

S.L. Guthrie, former distiller at Early Times, former bank teller and wheeler-dealer, purchased Wickland, Home of Three Governors, in 1930. His wife, six children and two sisters-in-law moved in after a complete renovation of the old house, which had housed tenant farmers and, for the last ten years, was used to shelter small animals and hay.

He discovered after he bought it that there was a still in the basement. Someone referred to it as a "steamer"—it piped the smoke up the chimney, hiding the distilling. The house had thirteen large rooms and three hallways. The family lived on the upper floors and also rented rooms to overnight visitors. They operated a "tea room" on the first floor for luncheons and other entertainments. It was still Prohibition and the early years of the Depression, so many Bardstown citizens took to renting out their homes for tourists or for "entertainment affairs." Mr. Guthrie was quite a card player, and many games were played in the parlor.

The Guthrie and Talbott families were large and sociable. Sunday afternoon visitors were always offered a drink. Lewis Guthrie had a store of bourbon in his bedroom from which he would draw out the Sunday libations. In his hurry one day, he forgot to close off the valve outlet, and the whiskey covered the wooden floor and dripped through the cracks between the planks and through the light fixture to the floor below. What a mess!

LaVerne Corbett spoke of her father and his still at Wickland when it was rented to tenants:

> My father also tells a story about having a still in Wickland. He ran it there during Prohibition. My uncle was working there when some of the agents came to make a raid. So he was tipped off. He ran up and got on the roof until they left. I believe there were two people caught there, but I don't recall who they were. This might have been after they ran out of whiskey that he went back to the still, after he ran out of whiskey from Tom Moore, hauling it there.

Will Stiles and S.L. Guthrie joined up with the idea to build a factory to make carpenter's levels—a new type—to provide jobs for people. The factory on Beal Street did produce some product but did not succeed. Daughter Nancy remembers her father pointing at something on their mantel and saying it had cost him $8,000. Of course, what he meant was that he had lost that in the level factory adventure. But this small story shows that even though both Prohibition and the Depression had hit Bardstown hard, those who could were always trying to build up the economy for themselves and for their neighbors.

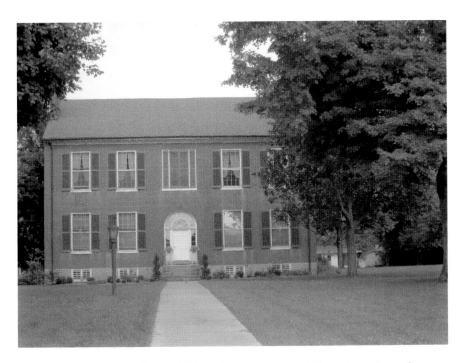

Wickland is known as the Home of Three Governors—two of Kentucky and one of Louisiana. During Prohibition years, it was also known to have a moonshine operation in the basement. The tenant family bragged that the federal agent who found it said, "This is the cleanest operation I ever found." *Photo courtesy of Dixie Hibbs collection.*

"It affected people at all levels of society," explained James Klotter, Kentucky state historian. "Some lost jobs, and Kentucky tax revenues fell because of lost business taxes. But others gained by going into business illegally." While Wall Street was flying high during the decade of the 1920s, America's farm economy was tanking. From 1920 to 1929, the value of American farmland dropped 30 to 40 percent, and from 1929 to 1932, farm prices fell 53 percent. Many distillers and distillery employees were farmers. Without the distilleries buying corn crops and salaries from distillery jobs, money was a very real problem for most Nelson Countians. While many nationwide looked at farmers during the Depression as lucky (they had food), the farm families in rural Nelson County had already been dealing with a devastating depression since 1920 due to Prohibition.

LAW ENFORCERS

*Alcohol and Tobacco agents roamed the countryside, watching for whiffs of smoke
that might be left over from the previous night's production. If they were lucky,
they found the stills idle, with no one in sight.*
—Kentucky Standard, *December 15, 1900*

During Prohibition, 126 federal agents were killed nationwide. Some were gunned down during still raids. At least one was pushed from a moving car by a moonshiner. A few died freakishly, scalded to death after falling into a vat of boiling mash or asphyxiated by the fumes of fermenting corn. One agent was maimed by a bootlegger whose brakes failed and slammed into a roadblock.

Moonshiners also sustained horrific injuries or died violent deaths. One federal agent was known to fire point blank into the skulls of captured bootleggers. And untold numbers of whiskey trippers burned to death when their cars rolled and their whiskey ignited after failed attempts at a sharp turn.

In general, local authorities in Nelson County and Bardstown steered clear of the enforcement of Prohibition. This was a federal law, and the federal authorities could deal with it. Besides, these were their friends, their buddies, their families. But that didn't mean that none of the locals was involved in law enforcement during the 1920s.

Awhile back, a ninety-five-year-old teacher told a timeworn story about the atmosphere during these years:

Taught at Samuels during that time. And that's when the bootleggers were so rampant down in there. And they would tell us, "Now the bootleggers have bought a certain road tonight, and they're going in this road. And tomorrow night, they'll go in a different road."

When asked what she meant by "bought the road," she replied, "They bought the road so the cops wouldn't be on that road to catch them." Samuels Distillery was also in the area.

Exciting chases up and down the hills and hairpin curves of Nelson County captured many bootleggers going to Louisville and "the big city market." At first, some of these "white mule runners" were out-of-county crooks who gambled that they could outrun or outwit country lawmen. They found it harder than they had thought. The successful moonshine runners were locals who had friends and relatives to help pay off magistrates and officers or reduce charges.

But the U.S. officials patrolled the roads and streets known as frequently traversed routes through Bardstown—particularly one known as "Alcohol Avenue" (North Fifth Street). On one occasion, when two hundred gallons of "moon" were discovered in a Ford on this street, the stash was poured into the ditch in front of St. Joseph's College and ignited. Somewhat ironically, this is the exact site of the Kentucky Bourbon Festival lawn activities today.

When "transporters" or "moonshiners" were arrested, their vehicles and stills were confiscated. When these vehicles were sold at auction, they were frequently purchased by other transporters, as they had been rebuilt to handle the loads of whiskey and modified for speed. The stills were destroyed on the spot. Destroying the whiskey could be a hazard. Two Prohibition officers were badly burned when a whiskey barrel exploded as they poured it on their smoldering fire. Most of the time, the whiskey and mash were dumped into the nearest waterway.

Archie Spalding and others told about what he called "the Big Pour." One time, there was so much whiskey dumped that townspeople and whomever could get there showed up with any kind of container they could grab. The idea was to capture the whiskey from the spring before it was diluted beyond use. Children, women and men were all there. Archie tells of several men who could find only cups standing hip-deep in water, dipping and drinking, dipping and drinking, until they could drink no more.

Warehouse robbery was yet another story. Thieves siphoned whiskey from the barrels with a hose and replaced it with water. They hauled the siphoned whiskey away in metal milk cans or just stole the barrels outright. Some distilleries were

hit multiple times in a few months. Local newspaper reports of the time tell of a "Whiskey Bobbery" in which enterprising gentlemen emptied whiskey barrels at T.W. Samuels Distillery, not realizing that they were taking the bourbon-flavored water used two years earlier to hide the previous theft. Thus the word "Bobbery."

The raids on reported stills were lively affairs, with shotguns and pistols being waved and discharged. In the July 14, 1921 *Kentucky Standard*, an emotional report noted that shots from an ambush wounded two officers and ignited public furor. A "posse" of more than one hundred "prominent business and professional men" from Bardstown was deputized to chase down the ambushers in the Mill Creek and Bear Creek areas. Two groups of men searched the two areas. The Bear Creek posse uncovered not one but five stills and wounded three "unidentified" moonshiners on Bear Creek. It was unclear if they had been the ambushers.

Everyone got in on the chase. Four Boy Scouts rafting down the Beech Fork River heard singing and smelled an odor that one described as "like Ma cooking biscuits." They told their parents and local officials, who then discovered a still and moonshiners. An "excellent Cadilac [*sic*], $100.00 fine, and 30 days in jail" was imposed on two men who pleaded guilty to transporting whiskey after ninety gallons of moonshine were discovered in their car.

Newspaper accounts of the period list the consequences of "the manufacture of spirits" in Bardstown:

> *First offense: $50–$500 fine and 2 to 6 months in jail, not to exceed 6 months*
> *2nd offense: 1–5 years in prison*
> *3rd offense: 2–10 years in jail*
> *Non-operating Still: $50–$500 fine plus 6 months in jail*

If the distillers or bootleggers were caught unawares, a gunfight ensued, with the moonshiner usually at the advantage. Agreeing to take a job as a revenuer was a dangerous proposition, but it was the Depression, and jobs were hard to find. Three things were necessary for a good moonshine still site: water, cover and wood. The hills of Kentucky are littered with the remains of illegal stills—bleak skeletons hacked into submission by zealous revenuers with axes.

Local newspaper accounts in the first six months of 1923 indicate that lawmen and lawbreakers were running all over Nelson County. Seven young men from the Bloomfield/Cox's Creek area joined up to rob the Old Joe Distillery in Lawrenceburg. They killed a guard and were caught. As the robbers were from prominent families, they were let out on bond and stood

In 1874, the Nelson County Court added a new jail building to the 1820 jail and built a stone wall around the work yard. This is a 1925 photograph. It is now a bed-and-breakfast serving tourists. *Photo courtesy of Nelson County Historical Association.*

trial about six months later. Two would serve prison terms of five years, while the others got off with lighter sentences.

A distillery guard at McKenna in Fairfield was shot three times during a robbery attempt but didn't die. Frequently, guards might be in on the heists and just looked the other way as long as it looked like the place was still intact. So thieves brought hoses and all the containers they could lay their hands on to siphon out the whiskey and "spirit" it away.

On March 15, 1923, a fourth robbery at T.W. Samuels took place. The guards were tied up, and 130 cases of whiskey were taken in a large truck. Owner Leslie Samuels and a deputy sheriff came from town in response to the phone call. They could see the tracks of a heavily loaded truck. Following the tracks down the road toward Bullitt County, they encountered a high-powered touring car coming toward them. Suspecting the robbers were driving the car, they carefully drove on until they found the truck, which had run off into a ditch when the load shifted. The deputy sheriff stayed with the truck while Samuels went to get help to dig the truck and the whiskey out of the ditch. As the deputy sheriff was standing there, he noticed two shadowy figures in the woods. Shots rang out; he jumped behind the truck and returned fire. Three shots were exchanged before the robbers ran off. Samuels came back with help, and they pulled the truck, still loaded with whiskey, from the ditch. Being robbed but recovering goods was not the usual end of the story.

Thieves looking for Bardstown's amber liquid didn't limit themselves to its geographic location. McClaskey & Son Distillery of Bloomfield was storing whiskey in Chicago for legal distribution when it was notified that the manager of the warehouse facility had stolen $175,000 worth of product. Bad luck!

In March, a judge made the ruling that no cars could be stopped and searched without a warrant. This was excellent news for bootleggers, and whiskey—both red (aged whiskey) and white (moonshine)—seemed to flood toward Louisville.

April is a fine month for cooking moonshine. Cold weather has passed and planting hasn't begun, so farmers have more time on their hands for other activities. The 1923 headlines announced that seven men and six stills were discovered between Holy Cross and Balltown early that month. The next week's headlines announced four stills destroyed in the same vicinity. And the following week's paper upped the score on moonshiners: ten men and five stills between Ball Town and New Haven. Stills were certainly in season. In July 1922, nine stills were located by agents, but not a single person was in sight. And on June 29 of the same year, a still was found at the bottom of a pond. Creative!

In 1922, headlines shook up the community. The largest robbery in years had been discovered at "Old Sutherland" on the New Haven road. One guard was tied up, and six or seven robbers siphoned whiskey from one hundred barrels into kegs. Twenty-two barrels were missing, and eighty-eight were left empty. Law officials were skeptical that the whiskey from the eighty-eight barrels could be siphoned in that short period of time. There was also disbelief that all of the whiskey was red; probably a lot was white.

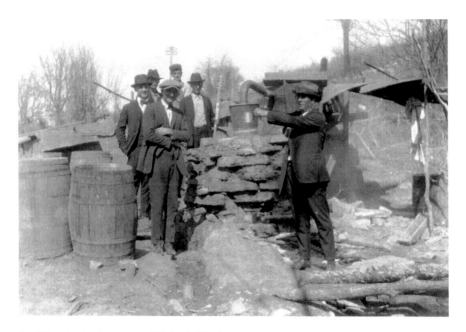

Joe Wheatley had set up an "illicit distilling" operation in 1926. Prohibition put a lot of legitimate distillers out of work but challenged others to continue to serve the market by making moonshine. This pictures show a moonshine operation alongside a creek that was needed for mash water and cooling water. The suited-up men are government "revenooers." It was the agent's job to search out and destroy all such operations. *Photo courtesy of Nelson County Historical Association.*

But further investigation would prove impossible as fire later destroyed the buildings. A newspaper account of June 15, 1922, states, "Sutherland Distillery Dry: Officers Discovered Whiskey Had Been Removed from 109 Barrels and Colored Moonshine Substituted."

But they were still locating stills and transporters, probably due to the high volume of moonshiners in the hills of Nelson and Marion Counties. The collector of revenue, Robert H. Lucas, based in Louisville, was outraged. He announced that if there was another incident (robbery) in Bardstown, "I will call the governor for state militia to take charge." The elected officials and prominent leaders of Bardstown met this with high indignation. They responded that the local elected lawmen were handling the problems. They also told Lucas that he should use the state guards to replace the dishonest revenue agents who were part of the problem.

And there were many times that raids and their aftermath turned the local citizens against the law. The February 17, 1921 issue of the *Kentucky Standard* reported the shooting and death of Marion Smith at the hands of nine

Prohibition agents as he and two others were operating a still near Mill Creek Bridge. Officers declared that one of the men, a "Negro," shot first, and they returned fire, killing Smith. This man escaped and was never charged. One officer named Blincoe declared that Smith had reached down for a gun, but no gun was found. Officers—eighteen strong and heavily armed—came into the area searching for stills and apparently split up. Neighbors who heard the altercation said there were no shots from the hill where Smith and his cohorts were standing. Tom Brent, found mostly submersed in the creek and thought to be heavily intoxicated, was taken prisoner. Marion Smith was thirty-eight years of age and a giant in size, being about six feet tall and weighing 260 pounds. He left a wife and five children ranging in age from three to fourteen.

Brent testified that the three were just walking along a hill to their car, a distance of about 165 yards, to go to his brother's when several cars pulled up at the gate, and men began piling out. Smith remembered the recent shooting at Mount Washington and suggested they run. Smith and the African American man did, but Brent stayed put until he heard the shots, at which point he fell over in a ditch and lay in the brush until they came up. He declared he wasn't drunk and didn't jump into the creek to hide.

Naturally, the officers' account of the raid differed substantially from Brent's and others'. They claimed they were shot at first and that they recovered two stills, which the men were assumedly operating prior to their arrival. The courtroom was packed to maximum capacity, but only thirteen women attended the trial. Twenty-four witnesses were called to testify, eight of whom were officers who participated in the raid. The ninth, Officer Walton, had been killed the day before the inquest.

Because one federal agent was shot and killed and a moonshiner was also killed, the local and federal lawmen and the moonshiners came to an informal agreement. The priests hosted a meeting between them to try to stop the killings. They told the moonshiners, "If you can run and get away, run, but if you are caught, take it, don't shoot." The lawmen were told the same: "If you can run him down, catch him, but don't shoot."

On December 1, 1921, the trial was over, and after only fifteen minutes the jury returned with its decision:

> *We, the Jury sworn and summoned by the Coroner, W.E. Crume, of Nelson County, find that Marion Smith came to his death by the hands of Prohibition Officers from a gunshot fired by said officers. We further believe that the killing from the evidence was unjustifiable.*

Lucy Smith, wife of Marion Smith, filed suit against the agents, and the federal lawyers attempted to get the trial moved into Jefferson County. Her lawyer convinced the court that justice would be better served in Nelson County, and the lawsuit for $20,000 in damages was held in Bardstown. Unfortunately, articles about further warrants or the disposition of Mrs. Smith's suit could not be found.

And on the Protestant side of the aisle, a well-known member of the Baptist Church, as the local story goes, was supplementing his income at this time by distributing moonshine. As he drove through town, he noted that a strange car was following him. Recognizing the law, he suddenly swerved down the street and pulled up behind the church.

Grabbing his box of illegal goods, he ran inside and hid the alcohol. The lawmen came into the sanctuary of the church and checked him out, searching the pews and corners, and since they had already searched his car and found nothing, they left shaking their heads. The lawbreaker wiped the sweat from his brow, walked over to the baptismal pool and pulled his jars of clear moonshine out of the water!

Living and breaking the law in a small town, even one where federal agents' efforts were concentrated, had its perks. Trusting them to return to finish their sentences, Jailer Lud McKay would allow the local moonshine and transporter prisoners to go home to their families for Christmas.

W.T. HAWKINS

Deputy Collector W.T. Hawkins and a posse of revenue men made a successful moonshine raid in Nelson County, about nine miles south of New Hope, on a Saturday night. They destroyed a flue copper still of 100 gallons' capacity, together with 150 gallons of singlings, a quantity of meal and malt and everything else necessary to a well-equipped moonshine distillery's toolkit.

Deputy Collector Hawkins reported it as the best-equipped moonshine still he had ever destroyed. No one was at the still at the time the raid was made, but the fire was burning in the furnace, and a pair of overalls; a jacket; a pair of socks; and a tin bucket filled with potatoes, eggs, pickles and bread were found, indicating that the night man heard the officers approaching, escaped in his nightclothes and left his lunch.

FRANK MATHER

In 1922, Bardstown farmer Frank Allen Mather signed on with the Treasury Department as a federal agent to scour Kentucky for signs of moonshiners. "You couldn't make much of an income on the farm back then, so my father always had a second job," said his son Sylvester. "When Prohibition started, he became an agent." And for more than a decade, Frank Mather spent his time prowling the backwoods of Kentucky searching for illegal stills and arresting moonshiners.

Enforcing the liquor laws didn't make him popular with the neighbors, and the family was frequently harassed. But among moonshiners, he was revered as honest and dedicated. Frank Mather arrested Archie Spalding more than once, but Spalding evaded him just as often. Archie and Mr. Mather's son, Pete, were best friends. They played baseball at New Haven:

> *I was at a game one time, and I always had whiskey with me. Mr. Mathers knew that. Well, Mr. Mathers hollered over to me and said, "What size shoe you wear, Archie? About an eight and a half?" "Yeah, why?" I asked. "I thought so. I think I found the box," Mr. Mathers answered. I knew right then what he had done, but he never did say no more about it...I don't think at no time that Mr. Mathers ever'd go out of his way to ever have caught me. Me and Pete wuz such good friends. But he would catch ye, don't misunderstand, and he wouldn't violate his oath fur to save his, I'll tell you that right now."*

Even though a revenuer took his life in his hands on every trip, Mather often took his son with him on raids. "We knew it was dangerous," said his son. "One time, my older brother, cousin and I all went with him and came upon a still, but the operator was gone. We stayed there all night until the owner came to work it the next morning, and my father caught him. This was someone my dad actually knew."

That moonshiner went peacefully, but often bullets flew. One would take Mather's life. According to the "Officer Down" memorial page:

> *Prohibition Agents Frank Mather, James Enoch, Marvin Fisher, J.S. Palmore, J.S. Payne and J.M. Gilliam; accompanied by Deputy U.S. Marshals and state constables went to Russellville, KY, to execute search warrants. They planned to raid a number of locations where undercover agents had previously purchased liquor. At the residence of Willie T.*

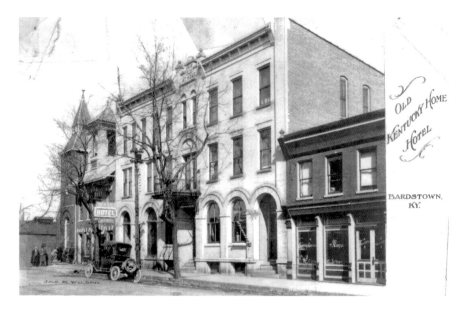

A postcard view of My Old Kentucky Home Hotel, built in 1914. Automobile traffic had begun to pass through the town on the way south, so a modern hotel was needed, and this one opened in 1914. It served visitors until 1969, when it was removed for the expansion of Town & Country Bank. *Photo courtesy of Dixie Hibbs collection.*

Thomas, agents found a still and arrested eight violators. The prisoners were all placed in one room within the house under the guard of Agent Mather and a Deputy U.S. Marshal while the others left to continue with additional raids. Sometime later, local officers unexpectedly showed up at the residence, all apparently under the influence of liquor and in the ensuing confusion, shots were fired. Agent Mather was seriously wounded and Bluch Soyars, a special deputy sheriff and also the Russellville Superintendent of Water, was killed when he attempted to release the prisoners. Agent Mather was taken to the hospital, but died the following morning.

BIG SIX HENDERSON

One of Kentucky's most famous "Prohi" officers was legendary William "Big Six" Henderson, known as the "Elliot Ness of moonshiners." He was known by the nickname "Big Six" for his resemblance to the baseball player of the same nickname, New York Giants pitcher Christy "Big Six" Mathewson.

Henderson was also an excellent baseball player, participating in leagues and pickup games in and around Bardstown. During the summer, Big Six and Archie Spalding played together in the New Haven Leagues.

A lanky revenuer who is purported to have arrested five thousand moonshiners in his nearly three-decades-long career, Henderson bragged he never had to hold any of them in custody; he simply told them to show up for arraignment on a given date, and they always kept their word. Henderson's career engendered a strange sort of professional relationship during his twenty-seven years of service as a U.S marshal and agent for the Federal Bureau of Alcohol, Tobacco and Firearms.

Suspects rarely gave up their real names, instead claiming to be Franklin Roosevelt, Daniel Boone, Abraham Lincoln, Charles Lindbergh, George Washington or Henry Ford. Revenuers considered moonshiners their prey, likening their job to deer hunting at an extreme level.

"It was a game, you against them," said one tax agent. Although generally Big Six's territory was Bowling Green, occasionally he was transferred temporarily to the local district, where he knew the moonshiners as friends and the revenuers assigned to central Kentucky both envied and resented him. Archie Spalding tells about one time when Big Six was set up by other agents to be embarrassed, but he turned it around. A tip sent him to the home of a local woman he knew. He had no choice but to search the house, but as hard as he searched, he could find nothing. Just as he was ready to give up, he noticed a crack behind the stove. He got behind the stove and found a door, which he opened and found clothes. Undaunted, he pushed the clothes aside and found 405 gallons of Archie Spalding's whiskey, which he confiscated and destroyed, much to the dismay of his duplicitous co-workers.

Revenuers and moonshiners came to know one another's names and families. A federal agent might arrest a man and send him to prison for two years and then help him find a job, a home or a girlfriend when he got out. Some moonshiners named their kids after revenuers they had feared and fled but whom they secretly admired.

The familial rivalry even influenced children's games. Instead of cowboys and Indians, children throughout Bardstown during the 1920s played bootleggers and revenuers. Sometimes they flipped coins to decide who would play the moonshiner and who would play the feds. Losers had to play the law.

LAWBREAKERS

Archie Spalding, his relatives and friends, were not violating their consciences or moral convictions—they were violating the prohibition laws—but otherwise they were good, honest and reliable citizens of the community and state. Archie Spalding and the majority of liquor law violators in Nelson County were certainly a different kind of moonshiner than the thousands of violators that I arrested in the hills of Kentucky, Tennessee or the large cities of the Midwest.
—"Big Six" Henderson, U.S. marshal and ATF agent

At the sixteen remaining distilleries, an effort to market the stored spirits before the ban had lowered some inventory, but many barrels resided in the warehouses. In March 1924, there were an estimated 600,000 gallons of whiskey in Nelson County, all of which were supposed to be under lock and key. Distillers, not to mention their customers, were less than pleased at the shutting down, closing up and guarding of the warehouses with all those barrels of whiskey just sitting there. You can guess what happened. Wicked minds, desperate to slake their thirst and fill their pockets, found ways to access all that stored alcohol.

Tales of owners or robbers sneaking into warehouses at night and siphoning off whiskey out of the barrels, then refilling them with water, are documented by many Bardstown residents. Jack Muir, in a recorded interview, tells about a moonshiner working at his still after nightfall, putting wood on the fire to keep it going. When agents swarmed around him, he ran until he fell down, whereupon he hid in the bushes. Shots kept coming

close to him, and he wondered about the accuracy of the revenuers until he realized he'd left his flashlight in his hip pocket and turned on! Once he switched it off, he was able to flee undetected but lost his still.

Fire!

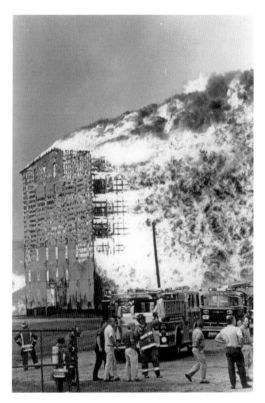

The Heaven Hill fire of 1996 was deemed the hottest fire to occur in the United States by ATF investigators and illustrates the many distillery fires during Prohibition used to cover up the theft of stored bourbon. Whiskey warehouses are wooden buildings full of wooden barrels filled with alcohol. If the wood is burning, water can be used to fight the fire, but once the whiskey starts to burn, water just spreads the flames. The flames reached a height of 330 feet. *Photo courtesy of Dixie Hibbs collection.*

In 1923, reports tell of watching huge flames, fed by alcohol, quickly consume warehouses that held barrels of the Queen of Nelson Brand. At Sutherland Distillery south of Bardstown, a huge number of barrels disappeared shortly after the enactment of Prohibition. Soon after, warehouses holding up to twenty-five thousand barrels went up in flames at the Mattingly & Moore Distillery. Finally, federal investigators had had enough. They suspected feigned arson to cover up the disappearance of thousands of barrels of the aging whiskey. And they were probably right.

When the warehouse at Mattingly & Moore went up in flames, investigators ordered it a crime scene and insisted on counting hoops in order to verify that the barrels had actually burned. No evidence of their report or the outcome of this investigation can be found; it was probably abandoned as futile. That's a lot of hoops in a lot of ash!

Tom Moore Distillery also caught fire, with burning whiskey flowing into the river. The flames were seen from five miles away. A stampede of cattle met the townspeople as they raced up the road. The cattle had been held in feeding pens at the distillery and managed to escape when the fire began. As this was the main road south, out of Bardstown, there was great concern that the covered bridge would catch fire and cut off several outlying communities.

DISTILLERY THEFTS

Then there was a robbery at the home of Mr. S.L. Guthrie. Mr. Guthrie, being in the whiskey business, was allowed to privately store whiskey. He had a vault built in the basement of his home at Early Times, where he kept about 250 cases of whiskey. One night, several men came to the Guthrie home—having cut through the telephone line and dismantled the cars on the property—and knocked on the door.

Mr. Guthrie thought the company who had just left was returning, so he went to the door without any concern. But when he opened the door, one man flashed a badge in his face and announced he was a revenue agent. Mr. Guthrie slammed the door in his face. But as the door closed, a pistol caught Mr. Guthrie's eye, and he opened it back up. What the intruders did next told the story of a very well-planned heist.

One of the men led Mr. Guthrie to the inside entrance to the basement and turned on the light, which was in an out-of-the-way place. Obviously, these men had been here before. Mrs. Guthrie had complained of hearing noises at night—feeling that someone, or something, was in the house.

According to Nancy Guthrie McKay, it was a man by the name of Paul from Fairfield who had cased the joint. Another man backed a truck up to the outside basement entrance and forced Guthrie to open the vault. While the thieves were loading the truck, Mr. and Mrs. Guthrie were guarded in the living room by Vernon, from Chicago. Mr. Guthrie and Vernon had quite a conversation. Vernon told them to take their jewelry off and put it away. He didn't want it, but the others might. Mother and Dad sat in the living room with Vernon. She took her rings off and pushed them down between the cushion and the side of her chair. Apparently, Mrs. Guthrie was furious and showed it to Vernon by being as nasty as she could. At one point, she asked to go to the bathroom, planning to escape out the bathroom window. Vernon followed her, foiling her plans.

When the truck roared off, Mr. Guthrie had somebody rush to a neighbor's place and telephone the officers. They thought Mr. Guthrie would be afraid to say anything. Roadblocks were quickly set out and clues followed to identify the thieves, who were known and dangerous criminals. The whiskey was found on a farm in Jefferson County, where the thieves had dug holes and buried it. Most of it was returned undamaged.

One month later, a 12:45 a.m. attempted robbery of T.W. Samuels was front-page news everywhere. Three night guards were surprised when shots were fired. They holed up in the guard shack and exchanged gunfire for forty-five minutes. No police officers came, as the distillery was ten miles out of town, but the band of eight to ten robbers pulled out after firing more than 220 shots. The guards sustained only minor injuries but had foiled the robbery.

This wasn't the end of the tale. Ten days later, police in Waukegan, Illinois, outside Chicago, arrested three wounded men after questioning them about the attempted robbery of Samuels's distillery. They turned out to be part of a gang that was responsible for several robberies in the Bardstown area. The first one to confess implicated two former Louisville police captains who were operating a roadhouse in Jefferson County. The confessor admitted that the owner of the roadhouse was paying him $1,000 a barrel delivered to the roadhouse. He said he had stolen thousands of gallons of whiskey and taken them to Louisville. Further information from the confessor implicated a gang of twenty men who had been former soldiers in the U.S. Cavalry. He and others indicated that it was their role to keep the whiskey flowing into the Chicago area.

After the attempted robbery of the distillery, the thieves kidnapped a doctor to tend to the wounded men from the shootout at the distillery. The man believed to be the ringleader of the gang was arrested as he returned to Bardstown from Memphis. He claimed his injuries were from an automobile accident. He was lodged in the Nelson County jail to await federal officers. When the three suspects were brought from the Chicago area to be tried, the confessor claimed he was beaten and didn't know what he signed.

T.W. Samuels Distillery was the target of the multiple robberies in 1922–23. In August 1922, a dozen bandits tied up the three guards and loaded a two-horse wagon with forty-seven cases of choice whiskey.

The next week's newspaper reported that public officials had traced the two mules and wagon to a local farmhouse where a man was identified as the one who transported the cases of whiskey. But not the man, the mules or the wagon was found. Deputy Hagen was convinced it was local robbers who stole the whiskey and not Louisville thieves as before. The wagon had

obviously gone through rough woodland and appeared to have met up with automobiles that probably took away the whiskey. He was convinced that the whiskey was long gone, along with the thieves.

In searching for the Samuels thieves, the local lawmen discovered two more men in the Samuels area who were in possession of whiskey. One had seven gallons of whiskey "for [his] personal use," and another had six gallons of "red" and sixteen gallons of "white" that he couldn't explain.

In December 1922, T.W. Samuels Distillery was hit again, and eighty-eight cases of bonded bourbon were taken. The guards were surprised between two and three o'clock in the morning and overcome by thieves, who made their escape in a truck and automobile. Police were notified throughout the state.

Apparently, the government men were always on the lookout for moonshiners, runners or drinkers. A simple horse-drawn wagon along a country road attracted the interest of the government men. When the driver realized the suited-up group was going to stop him, he jumped from the wagon and ran off into the woods. When caught, and after the agents searched the wagon, all the apparatus except the actual still were found. The driver denied that he had any involvement in illegal distilling. He was held in the local jail until further investigation.

In October 1922, five men were arrested within two miles of Bardstown for manufacturing whiskey. One still had been located on the Gilkey Run Road toward Loretto and the other on Pottershop Road. All five were taken before Judge Brown and held over to the grand jury on $500 bond each.

In November of the same year, an announcement of the greatest raid yet against the moonshine stills resulted in eleven men captured and five stills destroyed. This was in the neighborhood between Holy Cross and the Monk's Chapel. The men arrested were all loaded on a truck and taken to Bardstown, where they were detained by the judge to be charged by the grand jury. They ranged in age from seventeen to seventy-five.

In August, three stolen barrels of Willow Spring whiskey were reported to the warehouse guard and investigated. The output from this distillery was considered one of the best manufactured in the county. The federal agents supposed that the thief had purloined the barrels for personal use, as the amount was so small.

Obviously, 1922 was a banner year for the success of the feds. During just the four months from June to September 1922, they bragged that forty to fifty stills were confiscated.

Folklore about this time period is told and retold by local storytellers. For example, a Sister of Charity at Nazareth told this story that the sisters

didn't drive and depended on generous supporters to help them make doctor's appointments and meetings in Louisville. They always traveled in pairs, dressed in flowing black habits with starched white bonnets. A local gentleman was always available when called to take them to the big city. Later, the sister said they discovered that he was an infamous bootlegger who transported illegal whiskey. Can't you just picture a big black sedan, two pious nuns exiting out the back door, with the bootlegger driver handing out mason jars on the other side of the car? That was one way to pay for the gas!

The Fun Never Ends!

No one could go in a restaurant or liquor store and buy alcohol any longer. But that didn't mean it wasn't available. In New Haven, a home existed that local tales say people just knew was a bootleg supplier. Thirsty customers drove up, knocked on the kitchen door and were invited in. For a quarter, they put an oilcloth covering on their kitchen table and customers could sit and have a home-brewed beer with friends—and with their new friends, the bootleggers. In Bardstown, would-be customers were directed to two local bootleggers. They were very trusting and even ran credit for good customers. Code words protected their identities, and they weren't arrested. Everyone knew but no one talked. The code words for getting moonshine were to knock and say, "Get me two dozen eggs."

The atmosphere in the town and county was very accepting of the widespread illegal activities. Everyone knew but no one told. Only a new car or well-dressed stranger coming around might mean someone would tip off the law. In Bardstown, it was known that informers were given fifty dollars for each arrest their information secured. In such hard times, that could feed a family for months, but most weren't about to sell out their friends. People in Bardstown and surrounding communities took care of one another.

Social life was not restricted. People brought their flasks and sometimes set them on the table at dances or parties and even in restaurants. You were only criticized if you got drunk or caused a fight. Then you might have to go to jail or at least be bailed out by your prominent father.

In an offhanded sort of way, Prohibition also contributed to a mystery that remains unsolved after all these decades. Samuel Crume Jr., twenty-one, was married to local socialite Curran Seeger, and they lived in an apartment in the Moore Building. Unfortunately for Curran, a well-known party girl,

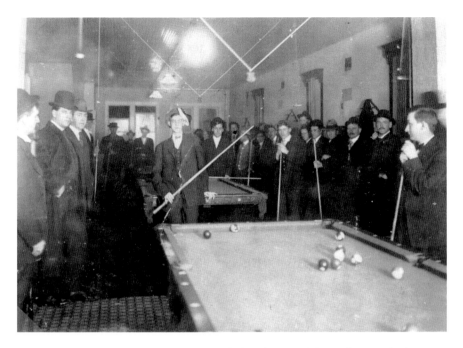

This poolroom was located on the east side of Main Street amid the saloons and other spots of entertainment. It was run by James "Sally" Mathews when this photo was taken but would be operated by the Stiles brothers during Prohibition. Notice almost everyone is wearing a hat. *Photo courtesy of Nelson County Historical Association.*

Samuel had a job at a distillery guarding the padlocked whiskey. The popular couple belonged to dance clubs and were both from prominent families. Late on March 9, 1922, neighbors to the Stiles heard what sounded like gunshots. Sometime later, Mrs. Stiles stumbled into her sister-in-law's apartment, bleeding from a gunshot wound. A bit later, Ogden Stiles stumbled into Stiles Billiard Parlor nearby and fell to the floor in front of the soft drink machine. He whispered two words to the poolroom manager, George Norris, but neither would tell what they were. Stiles was shot in three places, one through the muscle of the left arm, the second a flesh wound in the left side and the third through the chest, piercing the lung and coming out in back.

Both injured parties refused to say who had shot whom or if there had been a third party present. A neighbor said she had seen a shadow go past her door just after the gunshots, and according to the police, a lot more blood than expected was at the crime scene. No one saw Stiles enter or leave Mrs. Crume's apartment. They had been childhood friends, graduating from Bardstown High School at the same time.

On April 22, 1922, Ogden Stiles was charged with wounding Curran Crume. The trial date was set twice, needing a continuance to ensure that all forty witnesses who had been called could testify—to what remains a mystery. In the end, Stiles was let go, and to this day, no once really knows what happened. The Crumes remained married, and Ogden Stiles went on his merry—or whatever—way.

Because some entertaining was now taking place in homes, many who lived through the era surmised that perhaps even more drinking took place. Most women still didn't drink, but the making of home brew was a common practice in most households. And since it was the women who were home, they generally were involved. Home brew was a fermented, low-alcohol, beer-like drink that was offered to guests. As a rule, the ladies took compliments of a superior beer with pride. Local residents who actually imbibed this home brew say it was brewed (fermented) in the bathtub, but probably only for six days, as the tub would be needed for Saturday night scrubbings.

Local lore tells of Aunt Be-At Hurst, a sweet gray-haired lady of seventy years or more. She was said to have made home brew during the Prohibition years. Her home brew was judged to be the very best, the strongest, the tastiest of all in town. This churchgoing lady who chastised you for bad manners, sticking your fingers in pudding or sitting with your knees uncovered would have been your last suspect to make home brew. But she did.

She made it in the bathtub. Then she filled glass bottles, capped them and stored them at her friend's house, as she and her husband lived in a three-room apartment with one bath. Because she didn't sell her home brew—she gave it away—she escaped prosecution, even though everybody in town knew about her "hobby." Everyone wanted to socialize at Aunt Be-At's. We had hoped to find her recipe, but as in many cases, it was probably mostly in her head and in her experience.

Entertainments during the 1920s were similar to those of the decade before, but with more automobiles about, travel to other communities—and local roadhouses—was easier. The newspaper advertised weekly traveling tent shows that presented plays and musical performances. The Crystal Theatre had movies six nights a week. Dancing was a favorite activity for all ages. Fiddle contests, family bands and good piano players would stir up crowds, causing some to say, "We danced all night."

Even though whiskey is known to have been readily available, most accounts don't credit it with being necessary for all social occasions. Some people said that it was not acceptable at public events, but drinking at home was a personal choice.

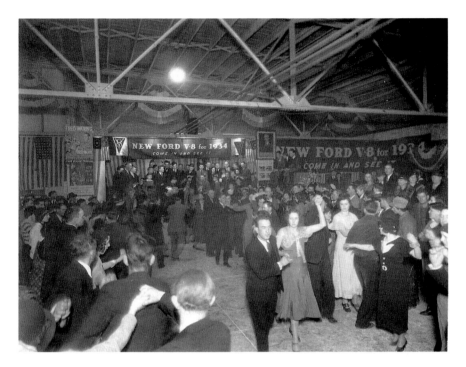

J.F. Conway liked to use his Ford garage for community events. This may have been the fiddlers' contest or a special square dance event in 1925. *Photo courtesy of Dixie Hibbs collection.*

When asked about playing piano for the silent movies during the late 1910s, Mary Crume spoke about playing in the dark. She played by ear and watched the screen to decide which songs should be played: romantic, chase songs for the cowboys, sad songs for the tears. She began her career at fourteen years of age. Her family was musical, and they often traveled to other communities to "play all night." She married in 1922, which sidelined her career.

During Prohibition, the town closed up when the Bardstown baseball team hosted a game. The Bumble Bee Baseball League involved teams from Lebanon, Springfield, Danville, Harrodsburg and Elizabethtown. On July 26, 1922, the boys of summer were Bardstown's "crack representative team." A special train brought along five hundred fans to cheer on the opposition from St. Mathews. The city school baseball field could hold one thousand spectators. The home team shut out the visitors 3–0, going on to win thirty-three out of forty games that summer.

During the busy summer of 1922 for revenue officers, the people of Bardstown were following their Bardstown Baseball Club, as it had a

The Old Opera House is now the War Memorial of Mid-America Museum. Since it was built in 1908, it was used for entertainments, basketball games, silent movies and a skating rink. Dances held during Prohibition created local diversion. *Photo courtesy of Dixie Hibbs collection.*

strong winning season. The team won forty-three times and lost only eleven times.

One of the highlights during the trip to Glasgow in August was when local fans experienced a first. The 150 fans who went to Glasgow witnessed the games in person, while in Bardstown, the Sweete Shoppe had made arrangements with the Cumberland Telephone and Telegraph Company to rent a wire direct to the game. Jack Irvine in Glasgow gave a play-by-play account as it was happening, which Clyde Norton received and provided to the 300 fans who could not go to the game. It was the first time ever for a small town to do this. The Bardstown team won both the Sunday and Monday games. Glasgow would visit Bardstown the following week and started off winning the first game 6–5 in front of 2,000 fans. Then, on Monday, Bardstown came back and beat Glasgow 4–2. The Sweete Shoppe invited all the visitors and the Glasgow team to the Big Dance.

Two years later, the nucleus of that same team went on to capture the semipro state title.

Take Your Medicine

Whiskey had been used for centuries for medicinal use and would continue to be available for that purpose. In the 1880s, a doctor's journal disclosed an unusual use:

> *Dr. H.D. Rodman of New Haven, Nelson County, kept an expense journal and then a little handwritten journal. And one of the expenses he had in there was "whiskey for Josie." Josie was his wife. He didn't buy it by the barrel, just a quart. In her later years she liked a spoon full of sugar that was saturated with bourbon at bedtime. It was a mystery for a while. Why whiskey for Josie? And then we found out through the family that you could always tell when she was expecting a baby, because he would buy this whiskey for Josie to try to keep her morning sickness down. She would eat that whiskey saturated in sugar. When you looked at these journals for about two months there he'd be buying whiskey for Josie. Then in six months or so, there was a new arrival.*

It wasn't hard to obtain legal whiskey during this time by getting a doctor's prescription and going to the local drugstore. Doctors were allowed to prescribe a pint of whiskey every ten days for one individual. Medicinal whiskey was bottled in one-pint bottles as a rule and was supposed to be marked medicinal whiskey, but often the bottlers didn't bother. A Bardstown doctor, who shall remain unnamed but was located in the Oakley building at the time, was well known for writing out prescriptions to whomever requested one of him. He was a very busy man. And when cleaning out an old drugstore basement in 1989, the owner found empty wooden cases of Willow Spring, made by his great-great-grandfather in Coon Hollow, Kentucky.

Cottage Industry to Big Business

The typical image of the "Kentucky moonshiner" is an old one and plays on stereotypes. Depicted as a barefoot mountain man or hillbilly with patches on his clothes, a battered straw hat, a corncob pipe in his mouth and a jug swinging from his finger marked XXX, this was hardly the case in Bardstown. In fact, whiskey-making was practiced in the 1700s

by legitimate, hardworking farmers—including none other than George Washington—both to provide liquor for the home and as an accepted way to enhance income. Until laws were passed criminalizing the practice, it was a respected craft, and the makers of fine whiskey were considered artisans in their own right. And today, with the advent of craft and artisan brands being revived and regenerated, the status of bourbon is again rising. The moonshiner has been generally accepted as a kind of folk hero—persecuted just enough to make folks aware he was a criminal.

Moonshining in Bardstown, as elsewhere in the country, was primarily a family affair until 1919. But with the advent of Prohibition, the demand for illegal alcohol skyrocketed, and suddenly home distillers were being called on to supply not only their regular customers but also those who previously had bought their liquor legally. When grain and corn prices fell as a precursor to the Depression, farmers realized that they could easily make more money turning corn into whiskey. One local report noted that nine stills had been destroyed on the same farm. Kentuckians are tenacious, you have to give them that.

Hattie Clements, a member of the Nelson County Historical Society, put in her memoirs that she wrote for her grandchildren:

When you went out on an early morning, you could smell the yeast on the breeze. And my father would say, "So and so's got his still going this morning." And sometimes we'd see a strange man ride by and Papa would say, "Well, Old Mr. Moore's snooping around again. He knows there's a still somewhere." There were certain men that possessed the art of the trade. People set them up to realize half of the proceeds without taking any of the chances. I had a friend that I went to school with, and she said that the girls at school ridiculed her because her father was serving time in jail. And the two girls that did most of the talking, it was their father that owned the still and that paid her father to take the rap. And she said she had to keep quiet because she knew her family would suffer if they didn't have that money. And you know, I bet those ladies today would say they didn't have a thing to do with moonshining. There were some people that made the whiskey just to get a few dollars to get their family out from a rock and a hard place. But there were others that tried to become wealthy, and they did. And there's still some of that money floating around in Nelson County today from those big moonshiners. I knew one lady, she told me that while her husband was serving time that she moved to Louisville and she rented a three-story house and set up a crew on the third floor. The house and the

crew were so well equipped that they could clear everything out within an hour. One day she said the officers came to the door and she told them that she was the maid. And they went to secure a warrant, and when they got back, everything was gone. I also knew another man that made whiskey in the hills of Washington County. And he realized a small amount of cash, but he used it very wisely and he set up a trade that changed the lives of many people in Washington and Nelson County. He became quite wealthy and died a very respected man.

People did not see whiskey as a vice. The only vice came out of the weakness in the people that abused it. People did not know that drinking was a disease, and looked down on the drunkard, not the one who provided the whiskey. I suppose I was about five and my brother was in and out of the hospital all the time. The doctor's bills were discussed with very sad faces. My brother was a hemophiliac. He had a blood disease, and very little was known about it in those days. The doctor said he would not live past sixteen. Papa wanted to take him to the special blood doctor. This was when my father decided to start a still. My mother was very much against it, but my father was sure he could get in it and out of it before anybody even knew it. He secured one of the local moonshiners and laid plans. The sacks of corn were put on the henhouse roof and kept there so the corn could sprout. I don't know what that had to do with it, but I just remember those sacks being up on the henhouse.

My uncle owned an old farm near us, and it was deserted and had grown up in bushes. The still was put near the springs, behind the old house. The thick underbrush hid it securely. It was on Sunday morning the mash was ready. My father started out that morning and when he got near the still, he said he thought there must be something wrong. It was just too quiet. The birds were usually singing. He didn't hear a thing. So he meandered down the path as if he were looking for his horses and calling them by name when an officer yelled, "Halt!" and jumped out in front of him. Papa said he mustered up all the courage he could to sound casual. He asked, "Have you seen any horses over here?" He said, "Mine got out last night. It's Sunday morning, and the kids have to go to church." The officer cautioned him to be quiet, and pulled him back in the bushes. He said he knew his man would be along in a minute, and he wondered what he could do to warn him. And when about that time he heard the clip clop of his boots and a merry whistling tune. About that time, the officer yelled, "Halt!" And Papa said he never saw such action in his life. Wood was off through the bushes like a rabbit. One boot went one way, another boot went

the other way. He wound up at our house with both socks raveled off up to the ankles. He put on my father's best suit and hat while my brother Ed saddled the horse. And he rode up the road past my father and the revenue officers. After Wood took off through the bushes, the officers asked Papa if he knew who that was. Papa answered, "I never knew anyone that could run that fast in my life." He said that was the truth. The officer was not sure this man with the nice soft voice was not implicated. So he told him he would have to take him in. Papa asked him if he could go home and tell his wife where he was and tell her he couldn't find the horses. After Wood had told Mama they would be along with Papa in a few minutes, Mama quickly put ham in the skillet and biscuits in the oven. Papa told the men they were free to search if they so desired. One of the officers seemed very suspicious. And I believe his name was, seemed like his name was Hunter. And he began to look around. And when Mama called them to breakfast, after he tasted Mama's red eye gravy, biscuits and ham, he soon forgot all about it. And can you believe the main guy left three dollars under his plate when he left. They never knew if it was Papa's acting or Mama's biscuits. But the main fellow looked at his men and said, "There's nothing here." Turned and thanked my mother for the breakfast, shook hands with my father, and left. This ended my father's career as a moonshiner.

Prohibition caused an increase in crime and a decrease in respect for the law of the United States. When grain prices became low as a precursor to the Great Depression, farmers were burning their crops in the field because it would cost more to harvest them than they could get for them on the market. But people knew that the corn could be made into a product that was easier to hide and highly desired across the nation.

LaVerne Corbett, another Nelson County Historical Society regular, tells of her distilling family's challenges during Prohibition. Her great-grandfather, grandfather, uncles and father had been involved with legal distilling—and continued to be involved with distilling after Prohibition. Her maternal great-grandfather, Henry Thomas Craven, was a distiller at Greenbriar Distilleries. Her grandfather Craven was a traveling distiller, riding the train a long way to help and oversee distillers until satisfied. She remembers him taking a gallon of sour mash with him on his rides. According to her, her grandfather was considered the best distiller in Kentucky at the time. His grandson Robert was distiller at Beam's—which was earlier called Churchill's. Robert worked with Booker Noe Sr. Most of her uncles worked with her great-grandfather and his sons.

Her father, however, took a different approach during Prohibition. He delivered whiskey that had been drained from barrels from Tom Moore Distillery to Louisville. Someone else, apparently, drained it, and the customers were responsible for the marketing and sale of the whiskey barrels. She remembers agents coming to the house without a warrant and being sent away, but by the time they returned, her dad and others had moved the whiskey to an unused quarry at the end of their fields. The children had spilled some of the whiskey, so the agents could smell it but couldn't find it, and no arrests were made.

When the whiskey from Tom Moore Distillery ran out, her father went back to distilling himself with stills hidden in various locations. At age eight or nine, when one still hidden in a neighbor's basement burned the house to the ground, she remembers being allowed to look at the disaster and seeing barrels all filled with mash:

> *This is another story that we were living here in Nelson County out on the farm. And one Sunday afternoon, we had gone horseback riding. We were really too little to be on horses, but we were. And we rode up in the woods and continued on until we were on some other people's property, which I do not know the owner. And we came up on this still that was being staked out. We did not know that it was being staked out, or we didn't know it was there. There was a lot of old hogs lying around because they were drunk. We would kick them, and they would just grunt. There was a lot of barrels of mash. Jugs of whiskey was there, corn and some sugar. Finally, three or four men appeared out of nowhere, and they were very angry with us because they said we messed up their raid.*

There were no jobs, no booze and no saloons. But Bardstown distillers did not let the law halt their age-old tradition of turning corn into comfort—or of sharing that comfort with others, for a price, of course. From early on, Kentucky earned a reputation as the illicit distilling capital of the nation. In 1877, the *New York Evening Post* went so far as to claim, "Nelson County, Ky., is the home of the moonshiner, the manufacturer of illicit whiskey."

As we've already plainly said, Bardstown is more than just a beautiful place; it offered near ideal conditions for whiskey-making. Kentucky corn grew prolifically, cold limestone springs sweetened the product and the locals had over a century of know-how. These factors, combined with an inbred suspicion for the law, created a subculture where moonshining thrived. And when you're making moonshine to sell, there has to be a way to get it to the customer.

Cars and trucks coming from New Haven, Balltown, New Hope and points south were stopped en route to or coming through Bardstown and searched. Often, they were stopped at the covered bridge over the Beech Fork River, one mile south of town. Some of these vehicles had been specially fitted with tanks and hidden reservoirs to haul moonshine or stolen whiskey. Farmers loaded false bottoms into the trucks and filled the remaining bed with produce to disguise their very real cargo. When transporters were stopped, it was noted whether it was white (moonshine) or red (aged whiskey). Frequently, the quantity of confiscated whiskey actually turned in was far less than what was actually retrieved. Agents got their "stash" free of charge when they stopped a moonshine runner with already packaged goods. Or they made a little extra cash by selling that same confiscated liquor to their friends.

The roads through Bardstown on the way to Louisville came together from Boston, New Haven and Springfield between Fourth and Fifth Streets on West Market in Louisville. This was another spot that agents targeted, as they knew the cars would turn north on Fifth to go to Louisville. When they were stopped, their liquid cargo was dumped into the gutter to drain down through Halligan's Canal, a large private drain built to drain most of the downtown Louisville streets and that emptied into the river about a half mile away. Each time, the neighbors could smell the dumped whiskey. The federal agents confiscated vehicles and arrested drivers. Later, they sold the cars and turned the culprits over to the federal court. Sometimes, the same cars would be on the road the day after the auction, bought by moonshine runners to continue hauling whiskey.

And so the wicked practice of distilling grain into liquor illegally flourished in Nelson and surrounding counties. Writes one historian, "Never again has so much moonshine been produced by so few." Ever the opportunists, farmers in Nelson County, seeing fast and easy profits doing something they were already experts at, jumped into the distilling business. After all, many of them had worked winter jobs at the best bourbon distilleries in the world.

Elsewhere, untrained distillers turned out a substandard product called "jake" that, in some cases, resulted in blindness, paralysis and even death. Bad moonshine could paralyze you or give you "jake leg"—paralysis or partial paralysis. This may have been the result of a stroke, perhaps caused by the bad 'shine. But Bardstown moonshine had a good reputation, so unless they drank barrels of it, those who imbibed the local brew did so worry free. Tales are told of ignorant men who used galvanized tubs to brew their mix, which leached lead into the brew and caused lead poisoning, but the experienced distillers in Bardstown knew better.

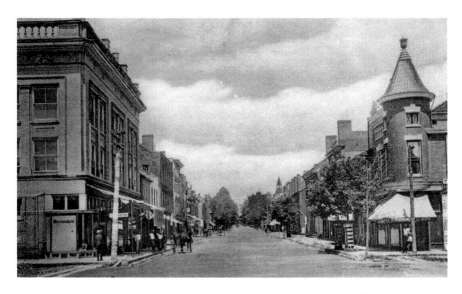

Looking north from the Court Square, this image shows the Johnson Building (1900) on the left and the new Jim Wilson Drugstore (1915) on the right. The telephone poles have been replaced with electric light poles. *Photo courtesy of Nelson County Historical Association.*

"Jake Walk Blues" (traditional)
I can't eat, I can't walk,
Been drinkin' mean Jake, Lord,
Now I can't walk...

In the seven years following the passage of the Prohibition Act, fifty thousand people reportedly died from the consumption of bad whiskey. In general, however, Bardstown moonshiners managed to keep their product pure, and the area's reputation for producing top-grade corn liquor, legally or illegally, only grew.

'Shine has purportedly gone by several names, including moonshine, white lightning, mountain dew, hooch, home brew, rotgut, bootleg and, probably owing to the kick, Kentucky mule. It is universally illegal and legendarily strong. In the words of one traditional folk song:

"Kentucky Bootlegger" (traditional)
One drop will make a rabbit whip a fool dog,
And a taste will make a rabbit whip a wild hog;
It'll make a toad spit in a black snake's face,
And make a hard shell preacher fall from grace.

In the old days, moonshiners used a basic pot still, usually copper. It was made up of two components: a boiler to cook the mash and a condenser to collect and cool the alcohol vapor back to a liquid. While effective, you don't get pure alcohol the first time. The fermented mash starts out at about 5 to 10 percent alcohol by volume (ABV), and after one run through, the still contains about 30 to 40 percent alcohol, the rest being mostly water. To raise the alcohol content, you have to save up all the results of your first runs and then run all of that through the still again, raising it up to the 60 to 70 percent range. Moonshine run through the still three times is very close to pure alcohol, above 80 percent ABV. The three XXXs caricatured on moonshine jugs indicate that the product has been run through three times and is almost pure alcohol.

But early on, there was no tried-and-true method of judging the alcohol content in each run. Being the inventive problem solvers that most frontiersmen are, they just mixed some of the whiskey with gunpowder and lit it. If the whiskey wasn't strong enough, the gunpowder wouldn't explode. But if it lit with a nice blue flame and burned evenly until only water was left, this was "proof" the whiskey was just right.

Moonshine could be as old as thirty minutes, thirty days or one year. It starts out clear but could be colored sometimes with iodine, sometimes with bark, sometimes with charcoal—anything that made it look aged. One story tells about using electric current to color moonshine. It was wise to always check to see if the maker was chewing tobacco—this could also be used to give it color. Ick!

REPRIEVE—REPEAL

After seventeen dry years, legal liquor is flowing again in Nelson county, ancient stronghold of Kentucky whiskeys.
—Kentucky Standard, *1933*

During the 1920s, the Eighteenth Amendment was widely assumed to be un-repealable, no matter how many people opposed it, how many moonshine stills were constructed or how many speakeasies or juke joints opened their doors for an increasingly thirsty public.

A review of the *Kentucky Standard* headlines ten years later lacked the weekly arrests of moonshiners and transporters. In fact, in three months during 1932, only one reference to an arrest of a whiskey manufacturer appeared. The grand jury reviewed only two or three charges compared to the fifteen to twenty-five charges during the same period in the early 1920s. The Great Depression was creeping into the economic problems that Bardstown had been experiencing for a decade. News of the late Prohibition era was concerned with highways, business and tourism. Local news dominated the front pages: fires, farm prices, government work programs, politics and politicians. In 1932, the election of Franklin Roosevelt resulted in the largest democratic majority in Bardstown history. His anti-Prohibition leanings were a major factor.

Interestingly, women played as large a role in Prohibition's repeal as they had in its passage, just as they had in every stage of the war on alcohol. It was assumed by most Americans that women would be the driving force to

keep Prohibition alive, that they would never allow its repeal. Senator Morris Sheppard, one of the authors of the amendment, was adamant: "There is as much chance of repealing the Eighteenth Amendment as there is for a hummingbird to fly to the planet Mars with the Washington Monument tied to its tail." Boy, was he wrong. And nowhere was a community happier to see it go than in Bardstown.

Repeal meant jobs, markets for corn and grain, food for livestock and so much more. It meant a thriving community again—or so it was hoped.

The Twenty-first Amendment, which repealed the Eighteenth Amendment, was passed in March 1933 and was sent out for ratification. Thus, distillers had a bit of a head start to gear up for full-scale operation after it became official.

Franklin Roosevelt had run on the promise to repeal the Eighteenth Amendment. Prohibition would be over. Equipment, leaking roofs and warehouses needing repairs were being catalogued. New distilleries were being planned. Former owners no longer had the resources to finance this endeavor; Prohibition had bankrupted most. Local whiskey families joined up with financiers from Chicago, Cincinnati and Pittsburgh to buy the new equipment and to reopen.

This wasn't the first time the distillery owners had gone outside Kentucky for funding. In 1900, Jim Beam had brought in Chicago investors Thomas C. Dennehy and J.S. Kenny as co-owners. T.W. Samuels rebuilt his family distillery after the fire of 1909 but sold controlling interest in 1913 to Starr Distillery of Cincinnati.

Repeal also offered the opportunity for small-town merchants to invest in a different industry, diversifying their investments. Longtime Bardstown residents and owners of the Louisville Stores, the Shapira family, bought into Heaven Hill Distilleries and are still very involved in its business.

Supply was an even more worrisome concern: supplies of aged whiskey were critically low. December 1933 saw America with only about twenty million gallons of whiskey on hand (compared to the sixty-some million gallons of surplus whiskey when Prohibition began). One possible solution was blending whiskey, which is the direction some distillers went under guidance from the National Distillers Products Corporation, formed as an indirect offshoot of the disreputable Whiskey Trust of the late 1800s. In 1933, National owned approximately 50 percent of all of the whiskey in the United States, along with a number of notable distilleries, such as the Wathen Distillery (Old Grand-Dad, Old Taylor and Old Crow), the Overholt Distillery (Old Overholt) and three other distilleries that produced straight

The cistern room at a local distillery is where the raw whiskey is piped into fifty-gallon barrels. The white oak barrel has been charred on the inside at the cooperage. The worker is using a bung hammer to knock the round wooden stopper into the hole where the whiskey goes in. Conveyer belts move the heavy barrel out of the cistern room to be loaded onto a truck and taken to the warehouse for aging. *Photo courtesy of Dixie Hibbs collection.*

whiskey. The company was acquired by the Jim Beam Brands Company in the 1980s.

The hope was that it would tide them over for a few years until they had enough aged straight whiskey to please the public. What they weren't considering, of course, was that once the public grew accustomed to blended whiskey, chances were they would never return to the "pure" stuff.

The whiskey men of America were nervous that much of their audience was gone. Bourbon is a labor-intensive and time-intensive product; therefore, it was hard to come by during the dry years. Beer, near bear, moonshine and gin were the easily made, quick-turnaround spirits that most bootleggers were making and selling across the country. During Prohibition, not only did the heady flavor of juniper help disguise just how poorly the liquor had been made, but it also gave the drinking public what they wanted: a highly flavored spirit. Since most people were used to the bold body and heady flavor of good whiskey, gin was preferable to vodka, a spirit that was

virtually unknown at the time. Even by 1939, when Charles H. Baker Jr.'s book, *The Gentleman's Companion*, was published, the author noted that vodka was "unnecessary to medium or small bars."

BALANCING THE BOOKS

Another worry some of the owners had was the knowledge that their inventory books weren't going to balance.

Not only had whiskey barrels been rolled right out from under the noses of warehouse guards over the years, but also remaining barrels might be filled with whiskey or they might be filled with water. Thieves (and owners) drained the whiskey and refilled them with spring water so the feds wouldn't be the wiser. And several of the intervening years had been far warmer than usual, accelerating evaporation—at least that's what some people used as an excuse for missing whiskey.

One story goes that a local owner was worried that repeal would bring inspectors to his warehouses, and he knew they wouldn't find what his records showed in 1920. He was completely aware that the barrels inside his warehouses held mostly water rather than aging bourbon. He is reported to have told his friends that he was determined to solve his problem with a fire. When his friends inquired about how the plan worked out, he responded with frustration that it took three tries to set the warehouse on fire because as soon as the barrels burned through, the water inside would put out the flames.

One tale of the distillers' dilemma, told forty years later, brought forth a story shared by a senior tourist from Chicago. "I know what happened to some of that whiskey." Of course, most people could guess what happened, but he went on to tell the tale:

> I was a salesman during the '20s and came to Bardstown as part of my route. I stopped at the Talbott Hotel, and after having a filling supper, I asked the waiter where I might find a drink. He asked, "Do you have two dollars?" I said that I did. He said, "Let me get you a mason jar." He left the dining room and returned from the kitchen with a pint jar and told me he had called a taxi. I went out the front and, sure enough, there was a ride waiting for me. He didn't even ask where I wanted to go; he just drove off. The only question he asked is if I had the two dollars. After a short drive, we pulled up to a metal gate with a guard standing alongside. The driver said to me, "Put

On November 7, 1996, a wind-driven warehouse fire became a disaster for Heaven Hill Distilleries. At 2:03 p.m., the alarm was sounded, and the Bardstown Volunteer Fire Department immediately responded. The first building, Warehouse I (left), is a pile of burning debris, quickly engulfed in flames. The heat and flames were blown horizontally to the next building, Warehouse J. Set in rows with more than 250 feet between them, this site had twenty-four warehouses. This photo was taken less than an hour after the alarm sounded. The fire continued to spread, consuming the warehouse on the right and four more warehouses and the distillery at the bottom of the hill. No lives were lost, and only one day of production was missed, as Heaven Hill leased a distillery in Louisville and continued producing whiskey. *Photo courtesy of Dixie Hibbs collection.*

your two dollars in the jar and give it to the man." Well, I did. Without a word, he took the jar and went off into the darkness. Well, I was from the big city, and I wasn't sure if my two dollars was gone forever, but shortly he returned with a jar full of bourbon instead of paper money. That is where some of the disappearing whiskey went. I drank it!

S.L. Guthrie, mentioned previously as former distiller at Early Times pre-Prohibition, was buying and bottling whiskey in Louisville and arranging to build a new distillery. In 1935, he sold the Wickland Plantation on the north side of Bloomfield Road. He contracted to build Fairfield Distillery on the

This 1949 picture of Fairfield Distillery shows when it was owned by Associated Kentucky Distilleries Co. The distillery was built in 1936 by Lewis Guthrie. Cliff Buzick built the warehouses—his first construction job in Nelson County. (His construction company is still building warehouses in Kentucky.) All of these buildings, except the warehouses, have been demolished. The warehouses are now owned and used by Heaven Hill Distillery. *Photo courtesy of Nelson County Historical Association.*

south side of Bloomfield Road adjacent to Bardstown. In 1936, he opened the distillery to produce several brands.

A tale has been told frequently about a mishap in the early years of Fairfield Distillery's production. The mash tub is the large two-story metal tank in which the grains and water are mixed and cooked, and it is usually open to allow steam to escape. The story goes that at one point a goat got into the distillery and fell into the mash tub. Most distilleries fight to keep birds, flies and other small animals out of the tubs, but it would be highly unusual for a goat to be inside the mash room. They say the goat was fished out before the cooking was finished. Since the mash is cooked at a high temperature, then sent to the fermenters to cool down and finally sent to the still, where the alcohol comes off as a vapor, there wouldn't be any bacterial problem. But was there a goat flavor in this particular batch? One gentleman was quoted as saying, "Well, a goat falling in didn't bother anything. He was just a dead goat, that's all."

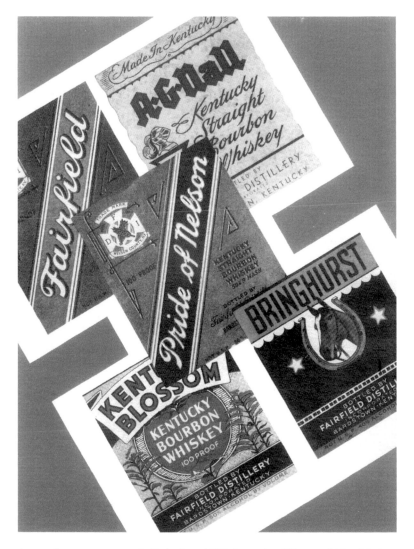

A page from a prospectus bulletin from 1938 shows the different whiskey labels registered with Fairfield Distillery, owned and operated by S.L. Guthrie in Bardstown. *Photo courtesy of Nelson County Historical Association.*

The *Kentucky Standard* reported that local distilleries were being outfitted and refurbished. It was going to be a race to see who would be the first to open. As the county awaited the final ratification of the Twenty-first Amendment, local distillers were refurbishing their plants—borrowing money near and far. The long drought and large influxes of cash that were going to be required meant looking elsewhere to reopen and begin work—which wouldn't pay off for at

least four years. New partners were brought in who weren't whiskey makers but who wanted in on the investment possibilities of an ancient craft. This changed the industry forever from family-run businesses to corporations with international involvement.

LEGAL LIQUOR RETURNS

In 1933, the *Kentucky Standard* newspaper announced: "After seventeen dry years, legal liquor is flowing again in Nelson county, ancient stronghold of Kentucky whiskeys." A review of issues from 1934 to 1937 reveals the following timeline for the reopening of the whiskey industry in the Nelson County area after repeal:

March 1, 1934: The first barrel of Bourbon Springs, the new brand of the reconditioned Clear Springs plant at Bourbon, was drawn last week [Bourbon, Kentucky, is on the railroad near Nazareth]. *Renamed the Bardstown Distillery, W.O. Stiles, and Charley Neuman are partners in the operation. On May 17, they announced they would "double its capacity to 600 bushels and will run to July 1st."*

March 8, 1934: H. McKenna, Inc. [in Fairfield] *is second to resume operation. The McKenna brand didn't lapse during prohibition as it was manufactured at a Louisville distillery for medicinal purposes. Coleman Bixler, distiller, will use some of the same yeast that was used when the distillery was closed. It has been kept in a copper jug during all that time and has been tested and found to be useable. This is the first liquor to flow since 1917. All buildings were kept in repair so that production can be resumed with minor reconstruction.*

May 3, 1934: T.W. Samuels Distillery, at Deatsville, will have their initial run of whiskey on Saturday morning (May 5), the third distillery to resume operation. It is an entirely new plant built adjacent to the railroad [the old plant was down the road toward Lenore]. *Consisting of one warehouse of 10,000 barrels, cistern house, a power house, drying house, and modern machinery, it houses practically every up-to-date machinery used in the manufacture of whiskey. Morgan Edelen is the distiller, having worked as distiller for Samuels since 1899. L.B. Samuels is vice-president*

and general manager, and his son T.W. Samuels is also associated with the distillery. The new distillery is financed with Cincinnati funds.

August 30, 1934: S.P. Lancaster Distillery is being rebuilt on the old site.

September 6, 1934: Tom Moore Distilling Co. has completed its plant on the former site and on Saturday will run its first whiskey into barrels. The reconstruction of the plant required more than a year. It has a capacity of 1,000 bushels a day. "In many cases the whiskey is being sold as rapidly as made with no opportunity to store any of the product for aging purposes." This is the third Bourbon and Rye plant to open. In the early autumn of 1933, Con P. Moore, son of the original founder of Tom Moore distillery, Louis Newman and Harry Tuer, both of Detroit, Michigan and others formed a syndicate to rebuild the distillery and manufacture whiskeys. The first run is Tom Moore brand. Woodcock and Rosebud, other well-known bourbon brands, will also be manufactured. In the year after reopening, thousands of barrels of whiskey were manufactured and shipped to California, New Orleans, Atlanta, New York, Chicago, Pittsburgh and elsewhere. The capacity has been doubled and the pace is so fast that "...all slop will be given away free to those who come for it."

March 28, 1935: The James B. Beam Distillery at Clermont has completed their first run of whiskey on March 25, 1935. They will produce five brands including Old Tub, F.G. Walker, Five Beams, Cave Hollow and Colonel James B. Beam. Five Beams refers to Jacob Beam, David Beam, J.H. Beam, J.B. Beam and T.J. Beam, all identified with the manufacture of fine whiskeys during the history of whiskey making in Kentucky. The plant is located on the old site of Murphy and Barber Company.

August 1, l935: Old Heaven Hill Distillery has been incorporated with capital stock of $50,000. Work is to begin on the plant at once, and is rumored to have a capacity of 200 bushels a day. The investors are M.P. Muir, Joe L. Beam, R.J. Nolan, and Gary Shapira. [A later story called it Heaven Hill Springs and indicates that Gary Shapira is president, and Ed Shapira general manager.] *Joe Beam is the master distiller and helped Joe Brant* [a Mohawk Indian from New York State], *the architect, to plan the buildings. H.D. Shain, distillery superintendent, was in charge of construction.*

September 26, 1935: The Cummins Distilling Corporation, owners and operators of the old J.M. Atherton Distillery in LaRue County, started production on August 13th after being shut down for 17 years. It is new and complete in every detail. Since opening, the orders are so great they have doubled the mashing.

January 25, 1936: The Old Greenbrier plant is to be put into operation, purchased by W.O. Stiles and J.F. Conway from Chicago capitalists in the spring of 1935. The partnership of Conway, Leo Smith and C.E. Keith will construct a plant and warehouse at Greenbrier, Ky on the site of the famous old distillery of that name located six miles east of Bardstown on the L&N Railroad.

May 28, 1936: A new distillery is being built on the Bloomfield road. Six structures are to be erected at once by the Fairfield Distillery Company. Walter C. Wagner, architect and engineer, is supervising the erection of a still building, fermenting house, power plant, government office, 10,000-barrel warehouse and a bottling plant. It is estimated to take three months to build.

Personnel at Barton Brands in 1956 celebrated the 900,000th barrel of whiskey produced at this distillery. Frank Kraus is leaning on the barrel. The tallest man on the left in the back is Sam Simpson. This distillery was Tom Moore in the 1890s and Barton's 1792 Distillery in 2015. *Photo courtesy of Dixie Hibbs collection.*

September 24, 1936: The Fairfield plant will get into production next month. An ironclad 20,000-barrel warehouse is waiting for the production estimated to be 600 bushels a day producing 60 barrels of whiskey. President S.L. Guthrie announces that Guy Beam is the chief distiller and "Pride of Nelson" brand the featured product.

September 24, 1936: Willett Distilling Company is to begin construction of a plant on the Loretto road with Thompson Willett president, Mary T. Willett, vice-president, and John L. Willett, secretary. John L. Willett is also the designer and engineer of the new plant. Lambert Willett, father of Thompson and John L., is the superintendent of Bernheim Distillery in Louisville.

Of the distilleries just listed as opening or reopening at the end of Prohibition, these are still in production: Heaven Hill, Barton Brands (Tom Moore), Willett and Jim Beam in Nelson County and Makers Mark (T.W. Samuels descendants) in Marion County.

The World War II Effort

Just about the time that the post-Prohibition distilled spirits reached the age to market and sell good bourbon, war in Europe erupted again, and American distillers were enlisted in the war effort. Distilleries were asked to produce industrial alcohol, and the distilling of spirits was rationed. Once again, whiskey supplies began to dwindle. Some brands were discontinued. The government gave distillers "distillation holidays" toward the end of the war, but frequently they continued processing neutral spirits to make a "blended" straight whiskey.

The industry took the time to help expand itself and create qualified employees to serve current and future needs. Jack Muir remembers that during the war, the JTS Brown Distillery ran a school for the other distilleries. Men would come and work with the distiller, the warehouse men and the bottling house employees to learn the craft. After they learned, they would go back to their distilleries. The men had gone away to war, and it was hard to keep help who knew what to do.

In fact, had Prohibition not ended, finding enough production capacity for the war needs would have been impossible. Industry documents of the

time state that industrial alcohol was used in a variety of fairly astounding ways: in the manufacture of rubber, antifreeze, tetraethyl lead (used in the production of aviation gasoline), rayon for parachutes and ether, among other things. Twenty-three gallons of industrial alcohol were required in the manufacture of a Jeep. Nineteen and three-quarters gallons were needed to produce one sixteen-inch naval shell. One gallon was needed to make sixty-four hand grenades or two 155mm howitzer shells.

As before, the leftover mash continued to be used as feed for farm animals—yet another contribution to the war effort by keeping cattle and pigs well fed when food for the general populace was at a premium. For every thousand bushels of corn used to make alcohol, the leftover mash fed thirty head of cattle and fifteen pigs for 112 days, producing 1,000 pounds of beef and 240 pounds of pork.

So the bourbon industry protected and fed the American public throughout the war, but there just wasn't much left for drinking. This hardly made the public happy. An editorial in the *New York World Telegram* in 1944 stated, "Public and official alarm over the shortage of liquor is pathetic in a people who are supposed to be adult."

UNINTENDED CONSEQUENCES

Do not always expect good to happen, but do not let evil take you by surprise.
—Czech proverb

As with any new idea that is instituted in the name of what we hope is progress, there are intended consequences—in this case, ending alcoholism and its all-too-often horrific outcomes. Prohibition did, in fact, have some positive outcomes:

- There is general agreement among social workers that there was a distinct improvement in standards of living among those with whom such workers come in contact, which must be attributed to Prohibition.
- Alcohol consumption during Prohibition declined between 30 and 50 percent.
- Deaths caused by cirrhosis of the liver in men dropped to 10.7 men per 100,000 in 1929 from 29.5 men per 100,000 in 1911.
- During the decade after Prohibition, social activists touted increased production, increased efficiency of labor, elimination of "Blue Mondays" and decrease in industrial accidents.
- Social activists also claimed there was an increase in savings and a decrease in demands on charities and social agencies.

But all implemented ideas also herald some negative unintended consequences. What the prohibitionists did not foresee, or in fact even

consider on any level, was how Prohibition would affect the nation negatively. Many ideas sound great at first glance but once put into action become a living nightmare for many. Below are listed the most notable.

- In 1910, Bardstown had 2,126 people and was a thriving, active community. By the next census in 1920, just one year after Prohibition was implemented, the population had shrunk to 1,717 souls.
- A byproduct of making any form of beverage alcohol from grain is the leftover mash, which is dried and used as feed for farm animals. Here again, the whiskey business contributed by keeping cattle and pigs well fed when food for the general populace was at a premium. As stated earlier, for every 1,000 bushels of corn used to make alcohol, the leftover mash could feed thirty head of cattle and fifteen pigs for 112 days, thus producing 1,000 pounds of beef and 240 pounds of pork. No more mash meant no more readily available, low-cost feed for producers.
- Inexperienced bootleggers (not those in Bardstown) took a shortcut and produced highly toxic methyl or wood alcohol instead of ethyl (beverage) alcohol. Methyl alcohol has a direct effect on the optic nerve, and as little as one ounce has been known to cause death.
- Ohio Valley women have been known to be ornery. But did you know they were the best bootleggers? Ohio Valley female bootleggers hid flasks in their dresses, drove trucks filled with whiskey and ran multimillion-dollar bootlegging operations before, during and after Prohibition. To this day, in the hills of dry counties, unsuspecting Ohio Valley women are evading taxes and selling booze.
- The Nineteenth Amendment, giving the vote to women, was ratified on August 18, 1920. Women's newfound freedom and empowerment came with the desire to keep up with men. Female alcoholism became a huge problem because more women had access to drink in a way they had never had before.
- All sorts of ploys were used to make this rotgut at least look good. Bootleggers colored their white lightning with ingredients such as iodine and tobacco spit to make it look as though it had been "in the wood" for a few years.
- Adulterated or contaminated liquor contributed to more than fifty thousand deaths nationally and many cases of blindness and paralysis. It's pretty safe to say this wouldn't have happened in a country where liquor production was monitored and regulated.

- The Depression caused a deficit in the federal budget that just happened to be equal to what the taxation of legal spirits would have brought in during a single year. On December 5, 1933, the Twenty-first Amendment was ratified, repealing Prohibition.
- National research indicates that by the end of the 1920s, there were more alcoholics and illegal drinking establishments than before Prohibition.

HERITAGE, HOSPITALITY AND HOOCH

As the economy worsened and Bardstown residents began to consider their options, several other "unintended consequences" began to form in their minds. The well-known Kentucky frontier ingenuity lit up and showed the way to economic survival. A plan began to hatch to focus efforts on promoting Bardstown as a major national tourist destination, a decision that would not have been promoted as quickly had it not been for Prohibition. And this was to be one of the major factors in the area's economic salvation. After all, what could be more "Kentucky" than Bardstown, one of its first, and most prestigious, towns?

In 1920, Bardstown already had over a century of experience offering hospitality to visitors. The earliest travel writer wrote in 1788 about the highlights of the growing town. In 1903 and 1904, the county hosted the National Fox Hunters Association meetings and fox hunts. The Louisville Auto Club passed through Bardstown in October 1909 as a first stop on a two-day competitive tour of Kentucky.

The opening of the Lincoln Farm Birthplace in Hodgenville, in next-door Larue County, stimulated an eight-county organization to promote the Central Lincoln Road through these counties (Jefferson, Bullitt, Spencer, LaRue, Nelson, Hart, Barren and Allen). In 1911, the Bardstown Commercial Club published a guide booklet about the attractions along the route from Louisville and other larger cities. The guide was to be sold, with one-fourth of the quarter price going toward the road fund. Listed attractions along the route included Federal Hill, St. Joseph Cathedral, Nazareth Academy, John

The Heaven Hill Trolley was used to transport visitors around the town and out to the Bourbon Heritage Center. The Talbott Tavern is in the background. *Photo courtesy of Dixie Hibbs collection.*

Fitch's grave (the memorial was dedicated in 1927), Gethsemane Abbey, St. Joseph's College, Lincoln Schoolhouse on Knob Creek and many natural scenic views. Published before Federal Hill opened to the public in 1923, it verifies that Bardstown already was a well-known tourist destination with much to offer.

A quote from the 1911 booklet puts this verbiage under a photo of a Main Street scene:

> *Those who love the old, the quaint, the beautiful, will gladly linger in a town full of these charms: a town whose homes, whose public buildings, whose sites and vicinity, are peopled by the shades of great ones, and vocal with the memories of their deeds. If there were a thousand roads to the Lincoln Home, this through Bardstown must forever be the one; since it alone can link the Civil War to the Revolution—the days of Lincoln to the days of Washington.*

The centennial celebration of St. Joseph Proto-Cathedral was celebrated over five days in July 1916. More than 1,500 people celebrated the date of the placing of the cornerstone by the first bishop, B.J. Flaget, on July 16, 1816. More events led up to the Thursday, July 20 dedication of the Centennial Memorial Monument. Clergy came from throughout the region, and newspaper coverage was widespread.

By 1920, automobiles were passing through the town daily. With major roads networking right through Bardstown, newspapers and travel agencies promoting family vacations in the new touring cars and a wealth of things to do and see, the entire town got in on the idea.

The Talbott Hotel, the new Old Kentucky Home Hotel and private homes were providing overnight accommodations. Owners of large (and expensive to run) homes with historical significance were happy to earn some cash by opening for tours and as what today would be known as bed-and-breakfast inns.

Gasoline was selling for twenty-two cents a gallon and moonshine for $2 a pint in 1923 Bardstown. Two large loaves of fresh bread cost fifteen cents, and a 1923 Chevrolet Superior two-passenger Roadster cost $510. The first organizational meetings for a local chamber of commerce were being held, and a nine-hole golf course was proposed but would not be built for several more decades.

KENTUCKY'S FIRST STATE PARK

Right when the situation seemed darkest, something fortuitous happened for Bardstown. Madge Rowan Frost was advancing in years, had no children and wanted to see Federal Hill, her family's home for generations, preserved. In 1920, Osso Stanley approached Mrs. Madge Rowan Frost about the possibility of purchasing the Rowan farm for a historic park. Visited by many locals and their guests over the years, it was acknowledged as Foster's inspiration. A $50,000 purchase price was agreed on, and a $7,000 option was paid in the fall of 1920.

Governor Edwin Morrow created the Old Kentucky Home Commission by appointing a committee of eight members, four from each political party. They kicked off a campaign in March 1921 whose slogan, "My Old Kentucky Home: Let's Buy It! Does It Touch Your Heart? Let It Touch Your Pocketbook," brought forth an outpouring of funds from successful Kentuckians in other states, as well as pennies from schoolchildren around

The Federal-style mansion built by John Rowan opened to the public in 1923 and is still welcoming visitors. The antebellum dress of the hostess recalls the period when Stephen Collins Foster composed his songs. *Photo courtesy of Dixie Hibbs collection.*

the commonwealth. Journalist Henry Watterson sent a $100 check with a letter of support. Successful New York theatrical magnate Marc Klaw was the first subscriber with a $2,500 check.

One hundred Bardstown citizens were among the audience who attended a special fundraising matinee of the play *Lightnin'* at the Macauley Theatre in Louisville. Bardstown's expected contribution was $12,000, raised by local events such as baseball games between local teams the Has-Beens and the Down & Outs.

In April 1921, to promote the project as a potential state park, the Fish and Game Commission designated the 236 acres around the mansion as a sanctuary for birds.

In August 1921, the My Old Kentucky Home Commission reported that fundraising efforts had produced $60,800—enough for the purchase price and the first payment on the option. Money to construct a road, erect a tablet about the park and make the necessary repairs to the house were still

Tourist cabins started springing up in the late 1920s. Some of these still exist in 2015. *Photo courtesy of Dixie Hibbs collection.*

required. A headline in the *Kentucky Standard* of March 16, 1922, noted the state would accept title, making it the "only State Park in Kentucky." It was also reported in that same issue that the legislature appropriated $20,000 to My Old Kentucky Home: $10,000 each year for two years and a sum of $4,000 a year thereafter.

The state legislature approved a $20,000 donation and yearly funding at the next session, punctuating the vote by singing Foster's song "My Old Kentucky Home." With this pledge in hand, work began to repaint and repaper the inside of the home. A water line was constructed from the water plant to the house, and the driveway was improved. A curator's house was designed but put aside until more funds were available. In November 1922, J.H. Mathews of Bardstown was employed to restore the furniture at Federal Hill.

A terrible wind and rainstorm in the spring of 1923 damaged the roof and set back the construction, but a valiant effort completed the repairs for the opening on July 4.

On July 4, 1923, a steady stream of traffic came into Bardstown from all directions to celebrate the opening of Federal Hill to the public as a Kentucky State Shrine. A special train from Louisville carrying 441 people arrived at the depot; 15,000 people gathered to dedicate the house that inspired Stephen C. Foster to write his famous song "My Old Kentucky Home." According to the *Kentucky Standard* of July 5, 1923:

Bardstown welcomed Kentucky and Pennsylvania yesterday. Welcomed home her sons and daughters from Kentucky and our sister state who came over 700 miles to honor the memory of the famous balladist.

The town awoke from its sleep Tuesday morning to find a gala spirit creep over its inhabitants. The stores were festooned with patriotic decorations, and down the avenues were flags and banners flung across the streets.

By 9 o'clock a steady stream of traffic was pouring into the city from all of the main highways. The traffic officers found its hard work to keep the metropolitanized streets from being congested. By noon, when the special train had arrived, the town presented the appearance of a busy city of some several hundred thousand souls.

It was truly a cosmopolite crowd which gathered on the grassy slopes of Federal Hill...Corpulent men and women, perspiring under the beaming rays of the mid-summer sun. Belles of the bluegrass and dapper young men. Tourist and wealthy famous families. Small children awed by the immense agitation. All mingled and jostled shoulders for they were all Kentuckians and Pennsylvanians, brought together in a common cause—to honor and pay tribute to the writer of a deathless song and the spot where he received his inspiration.

Anticipating the traffic, a select squad of twelve men on motorcycles was sent from the Louisville Police Force to handle the estimated six thousand cars that day. These diligent officers took their jobs a little too seriously when they embarrassed Mayor John Sisco: the mayor was stopped for speeding to the festivities.

The natural amphitheater at the front of the house supplied ample seating for the crowd. The audience enjoyed Foster melodies and patriotic airs played by the Tenth Infantry Band from Camp Knox. The ceremonies opened promptly at two o'clock. General Dwight Aultman raised the American flag on the pole amid the playing of "America" by the Camp Knox band under the direction of Captain Fisher. Arch H. Pulliam, vice-chairman of the Old Kentucky Home Commission, presented the site to the state and recognized a delegation of Foster relatives and dignitaries from Pittsburgh. Governor Edwin P. Morrow accepted the home as one of Kentucky's treasures and also recognized the gift of a portrait of Foster sent by the Pittsburgh Chamber of Commerce and the attendance of three generations of Foster's relatives from Pennsylvania. This event was the culmination of three years of planning and promotion and was the first of many such entertaining affairs at the "home."

Three local "belles" at the back door, welcoming visitors to My Old Kentucky Home in the 1930s. *Photo courtesy of Nelson County Historical Association.*

During the opening year of Federal Hill–My Old Kentucky Home as a state park, 8,136 people registered as visitors, a number outpacing even the most hopeful among the commission. The *Kentucky Standard* continued:

> *We are in the very place where he* [Foster] *and inspiration once met. We walk, perhaps, beneath the same old trees under which in the summer of 1852 he too walked and drew the soul of this home—the beauty of this scene in the spirit of the country, its waving corn tops, its meadows all in bloom, the plaintive melodies of the negro, the kindness and hospitality of a people, all, all into the alembic of his genius to send it forth again transformed to immortal melody. Here he caught out of the very air God's inspirations to His chosen one, and so was born the song, "My Old Kentucky Home, Good Night"—a song which blends in its heart of a melody the mysteries of twilight and moonrise, the glory of the breaking day, the tenderness of siren mother, crooning soft and low the light of hearthstone fires, faces of the adored, visions of the loved and lost, and which, speaking a universal language, tugs with memory's fingers at the heart strings of every wanderer as he hears the call of the land of his birth in the holy, tender, beautiful strains of "My Old Kentucky Home."*

The commission employed Colonel Ben LaBree, ex-Confederate soldier, historian and author, to be the first curator. As an aside, we would be remiss

as historians not to mention that LaBree's grandiose tales of the Rowan family, glorification of southern life and "English brick brought over the mountains by oxcarts" still haunt serious researchers as they delve into the story of Federal Hill.

On February 4, 1925, the last private owner of Federal Hill, Madge Rowan Frost, died at age seventy. Her coffin was placed in the hallway at Federal Hill until it was removed to St. Joseph Cathedral for a funeral Mass.

In March 1928, the Kentucky General Assembly would adopt a resolution making "My Old Kentucky Home" the official state song for Kentucky. The commission continued to maintain the house and estate until the Department of Conservation, Division of State Parks, took over the maintenance of the house and grounds in 1936.

INTERNATIONAL ACCLAIM

For the second time in its history, Bardstown was host to international royalty. In 1798, Louis Phillippe (later French King Louis VI) spent time enjoying the highlights of Bardstown. He stayed for two nights at Captain Banes's Tavern on his travels through America when he was under voluntary exile.

But it was on November 18, 1926, when Queen Marie of Rumania and her party arrived in a convoy of touring cars to visit My Old Kentucky Home. Congressman Ben Johnson was chairman of the Governor's Committee and escorted Her Highness. The party left Louisville at 11:30 a.m. for Bardstown, speeding at an average of forty-five miles per hour, led by two motorcycle policemen. Crowds of people lined the streets of Bardstown and greeted them as they drove to Federal Hill.

A luncheon was served in the home for sixty-five guests. The dining room table was set with the Johnson family china and decorated with flags of the United States and Rumania. Pink roses, ferns and lilies-of-the-valley were used in silver baskets on the queen's table. Vases of rosebuds decorated the sixteen tables set up in other rooms to accommodate all of the guests at the party. While the queen and the others ate, "a quartette of Negros rendered a musical program of southern melodies and Negro spirituals."

Afterward, the fifteen-car entourage paid a short visit to St. Joseph Cathedral, where the queen endeared herself to the crowd lining the sidewalk by singling out young Leo Haydon in his "rolling chair" for

The Honorable Ben Johnson was given the responsibility of representing the governor when Queen Marie of Rumania visited My Old Kentucky Home and St. Joseph Cathedral in Bardstown on November 18, 1926, with her party. He is shown here escorting her into the front door of the home. Note the forgotten broom beside the door, apparently left during a final tidying up. *Photo courtesy of Dixie Hibbs collection.*

Queen Marie of Rumania signed the guest book at My Old Kentucky Home as her son and daughter looked on. State and local officials joined her party in an elegant Kentucky lunch before leaving to visit St. Joseph Cathedral and the Lincoln Birthplace. *Photo courtesy of Dixie Hibbs collection.*

comments. She pinned her corsage of yellow roses and lilies-of-the-valley on the youngster. Then the motorcade raced off to Hodgenville and the Lincoln Memorial.

Who Invented the Steamboat?

On May 25, 1927, one thousand people gathered on the court square in Bardstown to hear Governor W.J. Fields state, "History has taught us, the text books in our schools have taught our children, that Robert Fulton was the inventor of the steamboat and the public accepted that teaching as true." He went on to say, "Yet a few people knew that it was not true." Through the efforts of Mrs. Ben Johnson and the John Fitch chapter of the DAR in Bardstown, the real inventor of the steamboat was honored that day with a stone memorial on the Bardstown court square. Bardstown had added yet another historic element to its tourism roster.

The band played "The Star-Spangled Banner" as the large crowd stood with heads bared during the solemn ceremony. The local schoolchildren sang "America" and "My Old Kentucky Home." Congressman Johnson gave an interesting summary of the history of Fitch's invention and the efforts to obtain congressional recognition and the necessary appropriation needed to build the monument. Five members of Fitch's family attended the ceremony. The local newspaper article noted that Charles Fitch, great-great-grandson of John Fitch, stated that he "had looked forward to a day such as this for fifty years." As a boy, he knew that his paternal sire had invented the steamboat and had so maintained, though he was punished for it in school when the teacher insisted Robert Fulton was the steamboat inventor.

Afterward, the John Fitch Chapter, DAR, hosted a luncheon for the dignitaries at the Sweet Shop. The guests dined on "Strawberries au Natural, Chicken, Country Ham, New Peas, New Potatoes, Hot Beaten Biscuits, Coffee, Olives, Radishes, Tomatoes with Cottage Cheese, Raspberry Ice and Angel Food Cake."

The effort to gain recognition of Fitch as the true inventor of the steamboat started in 1907, when Thurston Ballard of Louisville came to the local DAR chapter, known at the time as the Nathaniel Freeman Chapter, and asked, "Where is John Fitch buried?" A movement to erect a marker over this Revolutionary War soldier's grave began. Mrs. Ben Johnson became interested in his history and, through her research efforts,

uncovered documentary evidence to prove he had a working steamboat on the Delaware River in 1788, many years before Fulton.

Congressman Johnson introduced a bill in 1915 to recognize Fitch as the inventor of the steamboat and appropriate money for the memorial. The country's involvement in the world war prohibited any unnecessary appropriations, and the measure was tabled until after the war, when $15,000 was approved to erect a monument.

In January 1927, Presley-Leland Company of New York City began the stonework. Fitch's remains were removed from the cemetery and interred in the sarcophagus underneath the monument. Mrs. Johnson expressed great satisfaction in achieving this goal but said to the audience, "Now we must work to have the history books corrected to show that John Fitch was the real inventor of the steamboat." This is a battle still being fought.

Adding "Drama"

In 1959, enterprising citizens decided to capitalize on what was at the time a national trend: outdoor dramas. *The Stephen Foster Story* was one of several symphonic dramas by Paul Green. Green is considered the "Father of American symphonic dramas" and has worked since the 1930s with director Samuel Seldon, beginning with the *Lost Colony*. Scoring of Foster's melodies was accomplished by Isaac Van Grove, and the polished chorus was under the direction of Ralph Burrier. Period costumes, sprightly music of the era, dramatic lighting and a delightful story were set in the same location on the grounds of Federal Hill that may have provided the inspiration for many of Foster's best-loved songs.

The first season ended on a major high with gross receipts from all sources totaling $198,789, nearly $43,000 more than projected expenditures. The total attendance came close to seventy thousand. Souvenir programs were all gone in August—a first for any outdoor theater performance—and it was estimated that the first season alone brought over $1 million in business to Bardstown, prosperity that it had not enjoyed since Prohibition. A *Kentucky Standard* supplement for Bardstown's 200th anniversary reflected on that first season:

> *The weatherman provided a dry summer that allowed every scheduled performance except one. A check of auto licenses in the parking areas*

The Bardstown Tourmobile was used by many organizations. This is a group of citizens on their way to a farm tour organized by the Farm Bureau in the 1970s. *Photo courtesy of Dixie Hibbs collection.*

showed that 40 percent of drama attendance came from Louisville, that every county in Kentucky but one was represented and that visitors to the drama came from every state except Nevada and Alaska. Extra seats had to be put in the ampitheater during the last weeks of the season to accommodate the crowd. Original seating capacity was 1226.

This captivating presentation of The Stephen Foster Story *is already an important item of Kentuckiana and is well on its way to becoming an American Institution. Based on the success of this first 10-week season it should enjoy a run that will break all records.*

The Stephen Foster Story continues today, each time spring turns to summer, in the same location as it began in 1959. Each year, subtle and sometimes dramatic changes take place in the choreography, with the actors playing various parts and variations in some of the staging. But the story, and the synthesis of place, music and people, remains the same. Still a popular

Local chamber of commerce members and state tourism officials pose with an award for the successful *Stephen Foster Story*. Ben Guthrie and Kathryn Wycoff are the center accepters. *Photo courtesy of Nelson County Historical Association.*

outdoor theater venue, the Drama Association now stages what Bardstonians call "The Drama" and a musical each season.

In 1961, Bardstown built a tourist center on the court square. The purpose of the staffed building was to promote various businesses and locations in and around Bardstown to visiting tourists. The very next year, Heaven Hill Distillery offered to further promote tourism by providing a free "Tourmobile," which was a hop-on/hop-off visit to the area's top attractions, such as Wickland, My Old Kentucky Home and, of course, the distillery. This Tourmobile took several forms over the years it ran, including a decked-out bus and an open-air, wagon-drawn seating arrangement. Drivers of the vehicles served as tour guides, providing local history and stories as they navigated throughout the area.

On March 7, 1998, fire threatened to destroy one of the oldest buildings in Bardstown. The stone and brick Talbott Tavern, which had welcomed visitors for two hundred years, was burning. Local firefighters successfully contained the blaze, and the major damage was to the roof. Water was three feet deep in the basement and had damaged much of the wooden floors in the building. The building was repaired and reopened in November 1999, once again welcoming visitors to Bardstown. *Photo courtesy of Dixie Hibbs collection.*

A two-hundred-year retrospective published by the *Kentucky Standard* in 1980 provides an interesting glimpse into the tourist trade during those early, dry years:

- *Bardstown Hop Club organized to sponsor six dances per year in 1922*
- *"A History of Old Bardstown" published by Miss Nora McGee*
- *Annual Chautauqua was held here in July 1925 with speaker William Jennings Bryan*
- *Stephen Foster's 100th Birthday event in 1926, and Queen Marie of Rumania visits*
- *The John Fitch Monument is dedicated in 1927*
- *American Legion "Turtle Derby" and over 3,000 people visited "Greater Nelson Day" at Fountain Ferry Park, and Wickland was operating as an Inn, featuring old Southern cooking in 1931*
- *Weekly dances at Stiles Hall*
- *1,000 people attending the formal opening of the Louisville Road in 1932*

Many famous people have visited Bardstown throughout the years. The Talbott Tavern boasts of guests from Louis Philippe—heir to the French throne—to Jesse James to Abraham Lincoln's family to Queen Marie of Rumania to General George Patton.

Jimmy Carter; his wife, Rosalyn; and Vice President Walter Mondale visited in 1979. And Thomas Merton, philosopher, theologian and author of the bestseller *The Seven Storey Mountain*, visited Bardstown's Abbey of Gesthemane and decided to stay, living for most of his adult life in the monastery near Bardstown. He was known there as Father Louis.

Bardstown is now home to an Antique Show and a nationally known golf tournament, the "Bourbon Open," in June.

RUNNERS TO RACECAR DRIVERS

Prohibition brought another significant and completely unintended change—this time developing an entirely new sport around fast cars and racing. The young men (and women) of Bardstown found jobs as "red" (whiskey) and "white" (moonshine) whiskey runners. Moonshiners were working nonstop to meet the demand, and they adopted a new method of distribution to accommodate an ever-widening market. Souped-up cars became the general mode of delivery, and a new folk hero was added to the lore of the moonshiner: the transporter, or moonshine runner.

During Prohibition, revenue agents patrolled the roads most commonly used by drivers hauling loads of moonshine to bars and roadhouses. They were actually part of the problem. It became increasingly important for the moonshine runners to drive cars that were faster than the police vehicles pursuing them. The cars required a difficult balance between the load capacity to carry up to one hundred gallons of whiskey and the ability to quickly hit and maintain high speeds and negotiate curvy, bumpy country roads. As Robert Glenn "Junior" Johnson, champion stock car driver and former moonshine runner, put it:

> *Moonshiners put more time, energy, thought and love into their cars than any racer ever will. Lose on the track and you go home. Lose with a load of whiskey and you go to jail.*

Accounts in local newspapers tell an interesting story of stills and cars found abandoned, probably due to tipoffs from the same local police and federal agents who would then do the raiding. Archie Spalding, mentioned earlier as the head of the largest moonshining operation in Kentucky, told of many times when he drove right past agents he considered friends, going sixty-five or seventy-five miles per hour and loaded with a full car. Even when they had no choice but to pick him up, his father's connections (or his friendships with the agents) would mean that somehow the charges never actually stuck.

In the March 22 issue of the *Kentucky Standard*, that one day's headlines cite multiple arrests of hot rod runners carrying moonshine to the customers of said illegal product. Alphonsa Bowling was found guilty of moonshining and fined $200, with thirty days in the local jail. A 1920 Ford was stopped carrying seventy gallons of moonshine, and another car was carrying three hundred quarts of bonded whiskey. Time in the local jail was usually the sentence. To underscore the perceived severity of the crimes of moonshining and moonshine running, contrast these penalties with the eighteen months in the penitentiary given to the poor man who stole only a turkey hen.

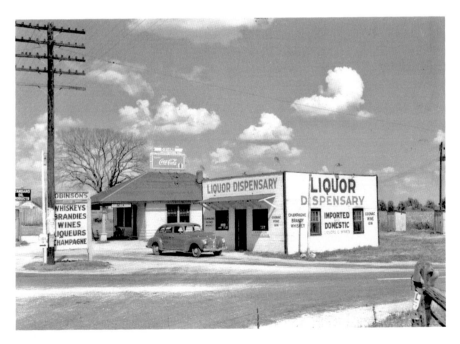

In 1940, a country "liquor dispensary" is handy for thirsty folks on U.S. 31E south of Bardstown. The gas pumps at the store next door are a good excuse to stop. The wooden outhouses indicate that the building has no running water. *Photo courtesy of Dixie Hibbs collection.*

In their off hours, runners would get together and race against one another. Hot rod racers came to planned local race events on Saturdays just by word of mouth. Dust flew, metal crunched and people cheered.

During the 1940s, the sons and grandsons, reliving their fathers' and grandfathers' escapes from the law, made the sport popular, and the drivers eventually took their muscle cars to the dirt track. In December 1947, a group of drivers and mechanics met in Daytona Beach, Florida, and established formal rules for racing, thereby creating the National Association for Stock Car Auto Racing: NASCAR. Moonshine runners had gone legit.

In 1995, the Bluegrass Speedway opened south of Bardstown near U.S. 31E and the Bluegrass Parkway. It hosted the Dirt Track World Championship (2002, 2003 and 2004) and also brought the Lucas Oil Late Model Dirt Series and World of Outlaws Late Model Series to the half-mile, high-banked clay oval, along with numerous other regional series that were instrumental in helping to get the track national television coverage on ESPN2, SPEED and the Outdoor Channel. The track closed with the end of the season in 2011.

The Prohibition era lasted from 1919 until 1933, when the Twenty-first Amendment repealed the ban. After Prohibition ended, illegal distilling didn't end, and it took decades for legal distilling to return to its pre-Prohibition levels. When marijuana surpassed moonshine as a cash crop, most illegal distillers turned to growing weed. Moonshine is still being made, of course—but now it's both legal and illegal.

A classic recipe for Apple Pie Moonshine is provided below for your entertainment. This recipe makes about nine quarts. It easily can be halved to make four and a half quarts.

APPLE PIE MOONSHINE

1 gallon apple cider
1 gallon apple juice
3 cups white sugar
8 cinnamon sticks
1 liter bottle 190-proof moonshine or grain alcohol

In a large stock pot, combine the apple cider, apple juice, sugar and cinnamon sticks. Bring it to a boil and then take it off the heat and allow it to cool. Add the liter of high-proof liquor.

Pour this into mason jars, put the lids on and let it mellow out. You could drink it right away, but it does get better after a couple of weeks.

Gasoline was selling for twenty-two cents a gallon and moonshine for two dollars a pint in 1923 Bardstown.

BOURBON REBORN

*Fill up, fill up, for wisdom cools
When e'er we let the wine rest.
Here's death to Prohibition's fools,
And every kind of vine-pest!*
—*Ambrose Bierce*

Today, Bardstown produces millions of gallons of bourbon whiskey from the same raw materials that the old distillers used. Modern technology—instead of wizened farmers and aproned bottling ladies—moves, empties and fills bottles with bourbon. We advertise and sell this product not just to our neighbors but also all over the world. But even with the devastation to the industry Prohibition caused, 2015 data indicates that at any given time, Kentucky has more barrels of bourbon aging than it has people—some 5.0 million barrels to its 4.2 million population.

But distillers weren't sure at the end of Prohibition that bourbon would ever reach the heights of popularity as it had in pre-Prohibition days. The end of the twentieth century saw, first, a decline in bourbon's popularity as a generation rebelled against their parents and their choice of drink and then, just after the millennium, a rebirth as the same generation discovered that whiskey had a variety of flavors and options. The twenty-first century has seen a resurgence in the popularity of bourbons and a growth in small-batch and craft distilleries not seen since Prohibition.

The April 1974 tornado destroyed one warehouse and heavily damaged four others at the Beam Distillery in Boston, Kentucky. This heap of lumber and barrels was a seven-story warehouse filled with twenty thousand barrels of bourbon only minutes before the tornado hit. *Photo courtesy of Dixie Hibbs collection.*

America's growth as an industrial nation is reflected in the distilling industry, which started as a cottage industry with farmer distillers using open flames and copper pot stills. The invention of practical steam power allowed the industry to grow into modern distilleries, with continuous column stills that require huge amounts of distiller's beer to make them cost effective. This beer could be supplied only by the growth of the railroads and steamships that not only provided access to the raw material from the countryside but also carried the finished product to markets.

As distilled spirits went from the raw corn whiskey of the frontier days of Kentucky to an aged product with a sweet taste and a smooth finish, marketing evolved. Early sales were often in unmarked jugs. As the product became aged in charred barrels, distillers would brand their names on the barrelheads. To protect their "brand names," the industry evolved a system of registering "trademarks" in liquor trade magazines. This started with simply showing an image of the mark on the barrelhead but quickly became more elaborate as distillers vied with one another to catch the eyes of customers. With the improvements in printing came color stationery and

Big bottles and little ones like these are examples of bourbon marketing. These are displayed at the Oscar Getz Museum of Whiskey History. *Photo courtesy of Doris Settles collection.*

advertisements for bourbon whiskey. Bar decanters, shot glasses, mirror art, bar trays and other items used in taverns soon became decorated with many of the brands that were popular at the bar.

After Prohibition, the industry became more regulated and the sale of alcohol more controlled in many states. The industry was creating jobs

and helping the nation climb out of the Great Depression when America entered the Second World War. Distilling was an important war industry as it transferred production to high-proof alcohol to make gunpowder and synthetic rubber. After the war, bourbon and other American products went everywhere the American Armed Forces were located. Military bases in Germany, Japan, the Philippines and elsewhere were brand ambassadors for Kentucky bourbon, positioning it as part of the world marketplace.

In the fifteen years that had passed since the beginning of wartime prohibition, much had changed. The industry had lost many of its skilled workers due to age and death. The nation was in the middle of the Great Depression, and the distilleries had to compete with Scotch and Canadian whiskeys that were ready to enter the market immediately, while American distillers would have to wait four years before they could have an aged product ready for the market. Times were tough, and they would not be getting better quickly. The Second World War brought back wartime prohibition, and it was 1946 before the distillers could begin to meet consumer demands for bourbon whiskey. But the public had developed a taste for other, less expensive and, for decades, more readily available beverages.

Suddenly, though, from out of the woodwork, Betty Ford, Ringo Starr and Liz Taylor came clean and publicly said goodbye to John Barleycorn, and a new interest in sobriety was born. When groups such as Mothers Against Drunk Driving (MADD) sprang up, the whole country started talking, once more, about the evils of drink. Happily, the atmosphere was nowhere near as oppressive as it had been for our forefathers at the beginning of the twentieth century. These groups took aim at irresponsible drinking. They were out to prevent accidents and to help those with drinking problems take care of themselves.

But in a strange, convoluted process, this new batch of concerned citizens not only did what they set out to do (for which they deserve much accolade), but they also paved the path for the return to the bold, rich flavors of straight American whiskey.

Sometime during the mid-1980s, people who might walk into a bar and throw twenty dollars on the counter and stay there until it was gone were no longer able to spend it on four or five screwdrivers or seven or eight beers. It wasn't politically correct, it wasn't good for the body and it was no longer a laughing matter. But these people still had the same amount of money to spend. So on what did they spend it? They spent it on the "good stuff." Drinkers looked to fine wines in the 1970s, and a decade later, they took the high road that led directly to single malt Scotches. And these were not the

bygone days when men were the sole decision-makers; by this time, women, too, had buying power—and had become discriminating consumers. The most avid of these budding aficionadas and aficionados worked at learning about their drinks. Some sat alone at the bar taking notes on the particular malt they were sampling; others assembled in groups, experienced a few different drams and discussed and compared each one's particular intricacies. And so it was that whiskey, albeit Scotch whiskey, was once again given the attention it deserved. And the American whiskey distillers took note.

Suddenly, liquor store shelves were filled with new bottlings of old brands of fine American whiskey; old-looking bottlings of new brands and a variety of new terms were being bandied about. Finally, "small-batch whiskey," "single-barrel whiskey" and "wheated bourbon" were getting their fair share of attention. Once again, people were demanding straight rye whiskey—not the blended product that had been poured as "rye" at many bars since as far back as the 1950s.

Most of the Bardstown distillers were resting comfortably, knowing that they have been producing fine, heavy-bodied whiskeys for centuries, while others who had "lightened" their products somewhat in an attempt to compete with gin, vodka and rum began, thankfully, rethinking their position. "Craft" bourbons are now popping up in many Kentucky distilleries, encouraging the state to add a "Craft Bourbon Trail" to its highly successful "Bourbon Trail," which showcases many of the distilleries in Bardstown.

The Bourbon Heritage Center at Heaven Hill Distillery was built of limestone, white oak and copper. Limestone spring water, white oak barrels and copper stills are the materials used in producing bourbon whiskey. Thousands visit the museum and gift shop each year. *Photo courtesy of Dixie Hibbs collection.*

This modern-day view of Barton's 1792 Distillery reflects the size of the distilling and bottling houses. *Photo courtesy of Dixie Hibbs collection.*

As consumers, we are lucky that so many good, straight American whiskeys are still left in the marketplace, lucky that the experiment that was Prohibition didn't eradicate the desire to make fine bourbon in this region so ideally suited to its distillation. The whiskeys—and the people who make them—have won a place in the hearts of the new connoisseurs. Raise a glass to the pioneers and heroes of the American whiskey industry of Bardstown: E.L. Miles, R.B. Hayden, Jacob Beam and his descendants, the Ford brothers, Wattie Boone, R.E. Wathan, George Garvin Brown, the Chapeze brothers, J.W. and J.H. Dant, McKenna, Tom Moore, Robert and T.W. Samuels, the Shapira brothers, Tom Currant, E.H. Taylor and W.L. Weller. And even after more than two hundred years, more early distillers are still being discovered.

RECIPES FROM THE
BOURBON CAPITAL OF THE WORLD

S ome women were adamantly against the use of whiskey as a beverage, but they had no problem using it for other purposes, and it was a staple for flavoring in cooking. In 1913, the Bardstown Woman's Club published a collection of recipes from the local ladies. It was dedicated to the "Young Ladies of the Bardstown High School, 1913." Included on the title page was the following toast:

> *A Toast*
> *A health to the girl that can dance like a dream;*
> *And the girl that can pound the piano;*
> *A health to the girl that writes verse by the ream,*
> *Or toys with high C in soprano;*
> *To the girl that can talk, and girl that does not;*
> *To the saint and the sweet little sinner;*
> *But here's to the cleverest girl of the lot,*
> *The girl that can cook a good dinner!*

There are several recipes in this cookbook that use a tablespoon or more of whiskey, but this first one uses half a pint!

FRUIT CAKE

1 pound butter
1 pound sugar
1 dozen eggs
1 pound flour
2 teaspoons cinnamon
¾ teaspoon ground cloves
2 tablespoons lemon juice
3 pounds raisins, cut in halves
1 pound currants
½ pound citron
1 pound figs, finely chopped
½ pint whiskey

Cream butter until very light; add sugar and beat well. Separate yolks and whites of eggs, and beat the yolks until thick and lemon colored. Beat the whites to a stiff froth. Add the yolks and then the whites to the creamed butter and sugar. Add flour, saving from this quantity a third of it to dredge fruit.

Now add cinnamon, cloves and lemon juice. Beat well, then dredge the raisins, figs and currants with saved flour and beat into the dough, adding the whiskey.

Bake slowly for 4 hours. [No temperature was given as women at that time were cooking on wood or coal stoves. Typically, a slow oven is 300 to 325 degrees Fahrenheit. This recipe was adapted from the one submitted by Mrs. Jasper Muir.]

BOURBON BALLS

Nothing says Kentucky like Bourbon Balls. Nearly every confectioner in the state has a signature recipe. Given out at airports on Derby Day and, in 2015, at the Breeder's Cup in Lexington, it is an integral part of Kentucky hospitality. Treated alternately as an appetizer, dessert or just a snack as drinks are poured, this chocolate favorite is a common sight on Bardstown sideboards.

1 cup pecans, slightly chopped
½ cup bourbon

½ cup butter

2 pounds confectioners' sugar

4 ounces semisweet chocolate, chopped

1 square paraffin [This can probably be omitted with today's
waxed chocolates.]

Pecan halves for garnish

Soak pecans in aged bourbon for at least 1 hour. Combine butter,
sugar and pecans until smooth. Add any remaining whiskey and
continue mixing until soft and doughy. Form into 1-inch balls.

Melt chocolate in a double boiler with paraffin over simmering,
not boiling, water. Stir until completely combined and smooth.

Dip balls into chocolate mixture with a spoon, turning to coat.
Place each on a waxed paper sheet. Add a pecan half to the top
of each ball. Continue until all balls are covered and decorated.
Refrigerate until set.

BOURBON PECAN PIE

*Variations on the famous Kerns Kitchen "Derby" pie abound with an amazing
number of variations on the name. This recipe not only includes the chocolate added
to the pecan pie but also adds bourbon to amp up the flavor just enough.*

1 cup white sugar

1 cup light corn syrup

½ cup butter

4 eggs

¼ cup bourbon

1 teaspoon vanilla

1 teaspoon salt

6 ounces semisweet chocolate chips

1 cup pecans, coarsely chopped

9-inch pie shell

Preheat oven to 325 degrees Fahrenheit (165 degrees Celsius).
In a small saucepan, combine sugar, corn syrup and butter or
margarine. Cook over medium heat, stirring constantly, until
butter or margarine melts and sugar dissolves. Cool slightly.

In a large bowl, combine eggs, bourbon, vanilla and salt. Mix well. Slowly pour sugar mixture into egg mixture, whisking constantly. Stir in chocolate chips and pecans. Pour mixture into pie shell. Bake in preheated oven for 50 to 55 minutes or until set and golden. May be served warm or chilled.

BOURBON BREAD PUDDING

Bread pudding is a well-known and well-loved southern dessert. Think bourbon-y cinnamon French toast with raisins. Fantastic.

2 cups sugar
½ gallon milk
8 eggs, beaten
2 teaspoons vanilla
2–3 quarts white bread, cubed
1 cup golden raisins
1 tablespoon cinnamon

Whisk sugar into milk until it completely dissolves. Add eggs and vanilla and stir well. Soak bread in mix for several hours or overnight. Pour into Pyrex dish or stainless steel pan. Sprinkle with raisins and cinnamon and "push" dry materials down into wet materials. Bake at 250 degrees Fahrenheit for approximately 1½ hours or until firm. While still warm, ladle sauce over and serve.

Sauce: Mix 1 full pound of softened butter with 2 pounds of confectioners' sugar until sugar is completely incorporated. Add 1 cup bourbon into mixture until it becomes the consistency of frosting. Serves 10–12.

BOURBON SILK COCKTAIL

Fill a blender with a handful of cracked ice and a pour of milk. Add a tablespoon each of brown sugar and chocolate syrup. Add a jigger of bourbon. Stir and strain into an old-fashioned glass.

BOURBON SOUR

Pour a jigger of bourbon into a cocktail shaker. Add juice of half a lemon and a half teaspoon of powdered sugar. Stir and strain into a fluted or old-fashioned glass. Add a maraschino cherry and a lemon or orange slice as garnish.

KENTUCKY MINT JULEP

Take your time making a mint julep, as it is revered as a taste of old Kentucky and an absolute must on the first Saturday in May while watching the Kentucky Derby.

Pack a silver julep cup with cracked ice and place it in the freezer to frost. Combine a tablespoon of sugar and three of water and add a sprig of mint. Crush the mint into the syrup with the back of a spoon to release the essential oils. This is a critical step and one often overlooked. Retrieve the julep cup from the freezer with a napkin (otherwise fingers may stick to the metal). Strain the syrup into the julep cup, add a jigger of bourbon and stir. Place a sprig of mint into the glass along with a silver stirrer/sipping straw just taller than the julep cup.

In lieu of the sterling, or perhaps even a souvenir glass from the Kentucky Derby, we suppose any glass and straw will do.

BOURBON MANHATTAN

Take a handful of ice cubes and place into a cocktail shaker. Pour in a jigger of bourbon and a capful of sweet vermouth. Stir and strain into a cocktail glass. Add a maraschino cherry as garnish.

BOURBON TODDY

Pack an old-fashioned glass with cracked ice to the rim. Add a teaspoon of sugar, a jigger of bourbon and a squeeze of lemon. Stir well and sip through a straw.

BOURBON OLD-FASHIONED

Make the Bourbon Toddy as directed above, add a dash of Angostura bitters, a quick pour of club soda and a maraschino cherry. Place a slice of lemon and a slice of orange on the rim of the glass and enjoy.

BIBLIOGRAPHY

Bardstown Chamber of Commerce. *Historic Bardstown and My Old Kentucky Home.* Louisville, KY: Breckel Press, n.d.

Burns, Ken, and Lynn Novick. *Prohibition.* PBS broadcast.

Butler, Mann. *A History of the Commonwealth of Kentucky.* Louisville, KY: Wilcox, Dickerman and Company, 1834.

Cecil, Sam K. *Bourbon: The Evolution of Kentucky Whiskey.* Nashville, TN: Turner Publishing Company, 2011.

Coleman, J. Winston, Jr. *Famous Kentucky Duels.* Lexington, KY: Henry Clay Press, 1969.

Conger, Kimberly H. "A Matter of Context: Christian Right Influence in U.S. State Republican Politics." *State Politics and Policy Quarterly* 10 (Fall): 248–69.

Cowdery, Charles K. *Bourbon, Straight: The Uncut and Unfiltered Story of American Whiskey.* Chicago: Made and Bottled in Kentucky, 2004.

"Distillers and Importers." http://www.pre-pro.com (accessed September 22, 2015).

BIBLIOGRAPHY

Elliott, Sam Carpenter. *The Nelson County Record: An Illustrated, Historical & Industrial Supplement.* 1886. Reprint, Bardstown, KY: Record Printing Co., 1973.

Fort, Shirley Durham. *Archie: A Kentucky Moonshining Tradition.* Louisville, KY: Press of the Aberdeen School of Writing and Related Arts, 1977.

Frendreis, John, and Raymond Tatalovich. "'A Hundred Miles of Dry': Religion and the Persistence of Prohibition in the U.S. States." *State Politics and Policy Quarterly* 10, no. 3 (Fall 2010), 302–19.

Graham, Coleen. "Bourbon History Timeline." About Food: Cocktails. http://cocktails.about.com/od/history/tp/bourbon_story.htm (accessed April 8, 2015).

Hanson, David. *Kentucky: Prohibition, Moonshine, Bootlegging, and Repeal.* Potsdam, NY: Alcohol Problems and Solutions, n.d. http://www.alcoholproblemsandsolutions.org.

Hibbs, Dixie. *Bardstown: Hospitality, History, and Bourbon.* Charleston, SC: Arcadia Press, 2002.

———. *Before Prohibition: Distilleries in Nelson County, Kentucky, 1880–1920.* New Hope, KY: St. Martin de Porres Print Shop, 2012.

———. Interview of Emma Wilson Brown. Kentucky Oral History Project. "Prohibition in Nelson County: The Causes and Effects, 1988–1989." Oscar Getz Museum of Bourbon History. September 27, 1988.

———. Interview of William Cross. Kentucky Oral History Project. "Prohibition in Nelson County: The Causes and Effects, 1988–1989." Oscar Getz Museum of Bourbon History. September 27, 1988.

———. Interview of Nancy and Phil McKay. Kentucky Oral History Project. "Prohibition in Nelson County: The Causes and Effects, 1988–1989." Oscar Getz Museum of Bourbon History. September 26, 1988.

———. Interview of Mary Beeler Moore. Kentucky Oral History Project. "Prohibition in Nelson County: The Causes and Effects, 1988–1989." Oscar Getz Museum of Bourbon History. May 31, 1989.

———. Interview of Jack Muir. Kentucky Oral History Project. "Prohibition in Nelson County: The Causes and Effects, 1988–1989." Oscar Getz Museum of Bourbon History. June 3, 1988.

———. Interview of Tate Rapier Spalding. Kentucky Oral History Project. "Prohibition in Nelson County: The Causes and Effects, 1988–1989." Oscar Getz Museum of Bourbon History. September 27, 1988.

———. Interview of Jack Stiles. Kentucky Oral History Project. "Prohibition in Nelson County: The Causes and Effects, 1988–1989." Oscar Getz Museum of Bourbon History. July 31, 1988.

———. Interview of Elizabeth Wathen Walls. Kentucky Oral History Project. "Prohibition in Nelson County: The Causes and Effects, 1988–1989." Oscar Getz Museum of Bourbon History. September 26, 1988.

———. *The Kentucky Standard Centennial History Book.* New Hope, KY: St. Martin de Porres Print Shop, 2001.

———. *Nelson County: A Portrait of the Civil War.* Charleston, SC: Arcadia Press, 1999.

———. *Nelson County, Kentucky: A Pictorial History.* Norfolk, VA: Donning Company, 1989.

———, et al. *Nelson County Kentucky, 1785–2010.* Morley, MO: Acclaim Press, 2010.

Higdon, James. *The Cornbread Mafia: A Homegrown Syndicate's Code of Silence and the Biggest Marijuana Bust in History.* Lanham, MD: Lyons Press, 2013.

Hite, Mary. Interview of Sam Kenneth Cecil. Kentucky Oral History Project. "Prohibition in Nelson County: The Causes and Effects, 1988–1989." Oscar Getz Museum of Bourbon History. N.d.

———. Interview of Hattie Clements. Kentucky Oral History Project. "Prohibition in Nelson County: The Causes and Effects, 1988–1989." Oscar Getz Museum of Bourbon History. N.d.

————. Interview of Laverne Kurtz Corbett. Kentucky Oral History Project. "Prohibition in Nelson County: The Causes and Effects, 1988–1989." Oscar Getz Museum of Bourbon History. May 29, 1989.

Holland, Jeffrey Scott. *Moonshine.* Unusual Kentucky. http://unusualkentucky.blogspot.com/2009/01/moonshine.html.

Howlett, Leon. *The Kentucky Bourbon Experience: A Visual Tour of Kentucky's Bourbon Distilleries.* Morley, MO: Acclaim Press, 2012.

Kentucky Standard. "A Closer Look at Nelson County History: 1785–1992." July 3, 1992.

————. "Moonshine Raid in Nelson." December 15, 1900.

————. "200 Years: Bardstown Bicentennial." June 26, 1980.

————. Various issues, 1918–36

The Kentucky Standard Guide to Bardstown and Nelson County Area. Bardstown, KY: Kentucky Standard, 1983.

(Louisville, KY) Courier-Journal. "A Bicentennial Salute to Kentucky." May 31, 1992.

————. "Our Towns." July 8, 1991.

Maurer, David W. *Kentucky Moonshine.* Lexington: University Press of Kentucky, 1974.

Maxey, Al. "A Bulldog for Jesus: Reflecting on the Life and Work of Carrie A. Nation." Blog. http://www.zianet.com/maxey/reflx335.htm (posted February 8, 2008).

McQueen, Keven. "Carrie Nation: Militant Prohibitionist." In *Offbeat Kentuckians: Legends to Lunatics.* Kuttawa, KY: McClanahan Publishing House, 2001.

Officer Down Memorial Page. http://www.odmp.org/officer/8683-special-agent-frank-allen-mather (accessed August 29, 2015).

Regan, Gary, and Mardee Haidin Regan. "History of Spirits in America." Distilled Spirits Council of the United States. http://www.discus.org/heritage/spirits (accessed August 2, 2015).

Smith, Sarah. *Historic Bardstown*. Shepherdsville, KY: Printers Publishing Company, 1968.

———. *Historic Nelson County*. Louisville, KY: Gateway Press, Inc., 1971.

Smith, Tim. "History of Shine." Timsmithmoonshine.com. http://timsmithmoonshine.com/moonshine.html.

Spaulding, Mattingly. *Bardstown: Town of Tradition*. Baltimore, MD: St. Mary's Press, 1942.

Spencer, John Henderson. *A History of Kentucky Baptists*. Eminence, KY: Baptist History, 1885.

Townsend, William H. *Lincoln and the Bluegrass*. Lexington: University of Kentucky Press, 1955.

Veach, Mike. "Distilling History." http://filsonhistorical.org/category/distilling-history (accessed March 6, 2013).

"Wickersham Commission: *West's Encyclopedia of American Law*." Encyclopedia.com. http://www.encyclopedia.com/doc/1G2-3437704708.html (accessed November 26, 2015).

INDEX

ABOUT THE AUTHORS

DIXIE HIBBS

Dixie Hibbs is a native Bardstown resident, born to native Kentuckians. Dixie was the first woman elected to the Bardstown City Council in 1982 and the first female mayor in 2003. She was also the first woman to be elected to the Kentucky Bourbon Hall of Fame in 2005; she won this honor by writing and talking about bourbon, not by making or drinking it. Retired from public service in 2007, she has nonetheless been involved in historic preservation since she was young. Her family has been involved in the renovation and restoration of fifteen local buildings.

Hibbs has served as president of the Nelson County Historical Society for more than twenty years and authored seventeen local and regional history books, several of which have gone into multiple printings. Currently, she is serving as executive director of Wickland, Home of Three Governors in Bardstown, managing the house and the nonprofit Friends of Wickland. She loves research and is called on often to help in historical detective work. Each summer, she arranges and coordinates a program for children, helping them learn the basics of history and historical research. This past summer, she included lessons on reading and writing in cursive, as this nearly lost art might someday make handwritten letters of centuries past, written in beautiful cursive script, indecipherable.

A mother of three, grandmother of five grandsons and great-grandmother of nine—both boys and girls—she persistently feeds them historical facts as often as they will allow.

DORIS DEAREN SETTLES

Doris Settles is a history junkie. Even as a child, she devoured history books, interviewed anyone who would stand still, signed on for folklore classes and just generally collected bits of interesting information that happened to come her way.

Kentuckian by birth to parents of a longtime Bardstown family, she spent every summer on her grandparents' porch, perfumed on hot, humid days with sour mash and the peaches they might be peeling for canning. Listening to stories and persistently asking questions of her grandparents and whoever sauntered by their North Third Street home, she fell in love with the tales and stories she heard.

Fortunately, writing gave her an outlet. Her bylines have appeared in magazines such as *Working Woman*, *Family Circle*, *Kentucky Monthly*; academic journals; and newspapers such as the *Kentucky Standard*, *Springfield Sun*, *Courier-Journal* and *Lexington Leader*, and she has published two books on technology culture. She taught English 101/102 at Lexington Community College and the University of Kentucky. Her academic background includes literature, journalism and instructional design.

She lives in Lexington, Kentucky, with her husband (a Bardstown native whose family came to Nelson County in the 1700s) and a very spoiled Pekingese, Ming. Their son and daughter-in-law live in Pittsburgh, Pennsylvania.

Visit us at
www.historypress.net

· ·

This title is also available as an e-book